FOOD PHOTOGRAPHY

Pro secrets for styling, lighting & shooting

Food Photography: Pro Secrets for Styling, Lighting & Shooting

10 9 8 7 6 5 4 3 2 1

First Edition

Published by Pixiq, an imprint of
Sterling Publishing Co., Inc.
387 Park Avenue South, New York, N.Y. 10016

This book is produced by
RotoVision SA
Sheridan House
114 Western Road
Hove
BN3 1DD

© Rotovision 2012

All images ©2012 Lara Ferroni unless otherwise specified.

Distributed in Canada by Sterling Publishing,
c/o Canadian Manda Group, 165 Dufferin Street
Toronto, Ontario, Canada M6K 3H6

If you have questions or comments about this book, please contact:

Pixiq
67 Broadway
Asheville, NC 28801
(828) 253-0467
www.pixiq.com
Manufactured in China

ISBN 13: 978-1-4547-0408-9

For information about custom editions, special sales, premium and
corporate purchases, please contact Sterling Special Sales Department
at 800-805-5489 or specialsales@sterlingpublishing.com.

For information about desk and examination copies available to
college and university professors, requests must be submitted to
academic@larkbooks.com.

For more information about digital photography, visit www.pixiq.com.

FOOD PHOTOGRAPHY

Pro secrets for styling, lighting & shooting

LARA FERRONI

CONTENTS

Section 4
Profiles & Case Studies 96

Introduction

Tell people that you're a food photographer and their eyes light up with visions of the dishes they've seen in the latest glossy magazines. "Do you get to eat all that food?" they ask, their mouths watering.

The answer is always in two parts: yes and no. Food photography and styling is about as diverse a category of food photography as you can imagine. For every huge-budget project that includes teams of stylists, banks of lights, but not even a nibble of food you'd want to eat, you'll find a shoot-from-the-hip, farm-to-table shoot where you go home with a bag of tasty goodies. Food photography expands outside of the realm of the glossy food magazine and cookbook to encompass advertising, packaging, catalogs, and television for food products, tableware, kitchen equipment, the travel industry, and lifestyle and health publications.

About this book

Starting a career in food photography or styling is a challenge. While some art schools allow for specialist study, few offer in-depth classes covering food photography. While more general classes, such as dramatic portraiture or still life, sometimes cover subjects similar to food photography, few of them really prepare you for real-world shoots.

This book aims to help those photographers who have a passion for food learn how to get started in the industry, to understand how the industry has developed, and to see where it is going in the future. To get the most out of this book you need to have a solid understanding of the basic principles of both photography and lighting. This is not a book on how to use your camera or how to set up a softbox—there are many great sources already available covering those basics.

This book also isn't a guide to being a food stylist, which is a highly skilled profession requiring strong culinary and artistic talents. Instead, this book describes the roles of stylists and photographers, and how they work together to produce great food images. However, recognizing that not all shoots have the budget for a stylist as well as a photographer, I have included tips for photographers who need to style their own shots. These tips scratch the surface of food and prop styling, but are sufficient for many projects.

This book will provide a complete reference to many different types of food photography shoots, it will describe how to think about light and food and how to work with chefs and clients, and it will give you specific case studies to help you understand how some of the top food photographers in the industry achieve their images.

Food photography is about making the most of beautiful food, from finished dishes and ingredients to the people that produce them

1. THE BASICS

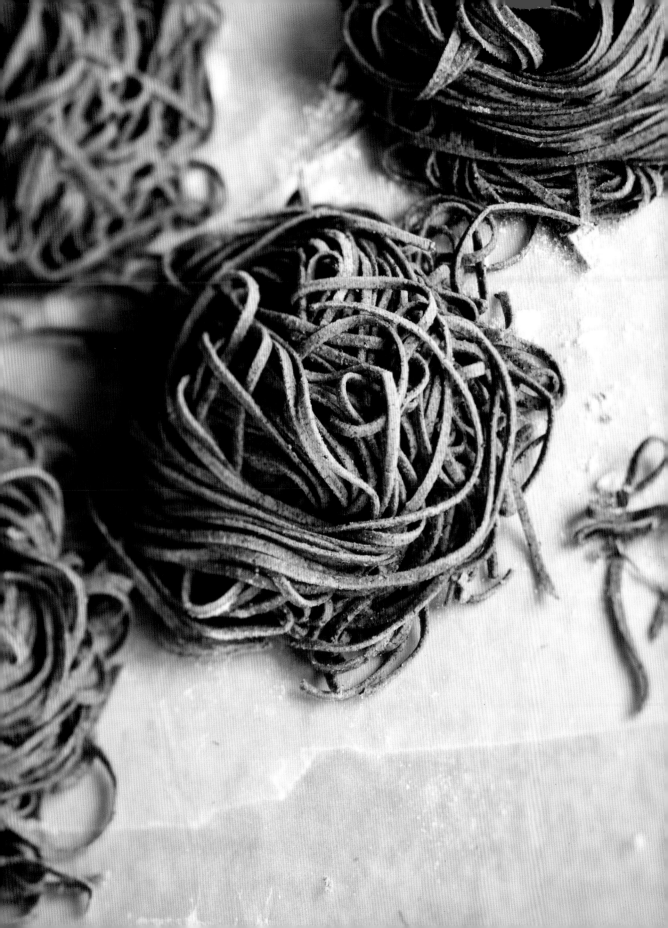

Types of food photography

Within the field of food photography there are many specializations requiring very different skill sets. Commercial food photographers tend to focus on photography for advertising and packaging, for example, while editorial food photographers are more likely to shoot for cookbooks and magazines. Most photographers do a little of both types—commercial to pay the bills, editorial to have fun—but usually tend more toward one than the other.

1. Advertising

Advertising shots are all about selling a product. Traditionally these shots are highly produced, with each aspect of the product and setting looking "perfect." However, advertising work is also influenced by current trends in editorial photography, and some of the styling done for advertising has started to show a more relaxed, natural look, even at times bordering on a beautiful mess. Still, as a general rule, most advertising (and even "advertorials," which introduce content, such as a recipe, with the advert) features meticulously styled and highly lit shots.

Most products are presented as "serving suggestions," which allows for some flexibility in their styling, such as putting fresh fruit in cereal. In addition, not all of the food in the shot needs to be real. If the product is a pancake mix, for example, then the pancakes must be made as the package instructs, but the syrup could be motor oil (which appears on camera as a thick, golden syrup). And cereal is often photographed floating in glue rather than milk.

2. Packaging

Like advertising shots, product packaging shots are a selling exercise, so they need to show whatever the subject is in the best possible light. However, shots for packaging have special needs. They are often printed on nonstandard papers or plastics, they may need to be printed quite small, and they may need to work with a specific layout. Packaging shots also often require strict documentation of the camera, lighting, and prop positions so that the image can be recreated with other, related products at a later date. In styling food for packaging, it is critical to represent the product accurately. As in advertising, "serving suggestions" are allowed, but portion size must be closely controlled and depicted.

3. Catalogs

Food photographs for catalogs are often more about cooking-related products than food itself, giving the stylist and photographer a lot of freedom. However, many catalog shots also require the food or product to be easily knocked out, or deleted, and, like packaging shots, may require extensive documentation to ensure that related products can be added later without looking out of place or requiring an entire new shoot.

Advertising

Advertising

Packaging

Catalog

11

Recipes

Restaurants

4. Recipes

Arguably the most common form of food photography
are recipe shots. Whether they are for a magazine article,
cookbook, or website, recipe shots require an edible finished
dish, and should represent the best presentation of a
given recipe that can be achieved by following the steps of
the recipe.

Recipe photographs can be of the finished dish, the
ingredients, or the dish preparation. These shots usually have
a lifestyle or editorial style, which is a bit looser than the
"perfection" required of advertising or packaging shots.

5. Restaurants

Restaurant photographs tend to be for editorial purposes
(such as a feature in a magazine), advertising, or (often in
the case of fast food) menus. In most restaurant shoots, the
kitchen personnel or chef prepares the dishes, only
occasionally with help from a food stylist.

6. Stock photography

There is a good market for stock food pictures, for both
rights-managed and royalty-free imagery, which can provide
a modest income stream from images that may not have been
selected from a commissioned shoot. Most agencies have a
significant library of food photographs, and a few specialize

only in food. Stock agencies look for images that follow popular trends, and are flexible enough to be used in different contexts. Most agencies share a "wish list" with their contributing photographers.

7. Video and television

Cooking programs on television and food advertisements have been around just about as long as the television industry itself. But recent developments in DSLRs have opened up the market to a new generation of photographers. Instead of having to learn an entire new system, photographers can use their DSLRs, with all their lenses, to record short, trailer-like, high-definition video for a whole range of food-related subjects.

8. Websites, blogs, and eBooks

Food photographs on the web have been largely the realm of the amateur, with food blogs detailing everything from morning breakfast rituals to specialized allergen-free diets, and the quality ranges from cell-phone snaps to pro-quality images with intricate food styling. Food blog photography focuses on real food (usually taken in natural light) that rouses, or at least attempts to, the desire to "eat the food off the screen."

But food photography on the web is a much broader subject area than hobby food blogs. Celebrity chefs, food-product companies, and publishing companies—with their need for frequent, seasonal updates with artwork that rivals the glossies—have opened up a new market for the professional. Enter the tablet computer and other mobile devices, and the world shifts from print to electronics even a bit more. While producing images for the web relies on the same skill set as those for print, the projects are more timely, schedules are tighter, and no one quite understands the business side yet.

Blogs

Blogs

Food photography trends

As in most areas of photography, trends in food photography come and go. In the 1980s food was styled to the back teeth. Props were shiny and black plates prevailed. Food was done up like it was going to the prom. In the 1990s, however, food styles started to relax, with still elegant white on white, but there was a hint of real life with a crumb here or a bite there. Lighting was controlled, but focus softened.

The 2000s marked a new interest in food, particularly all things that were local and organic. Food photography has reflected this by giving an almost grungy realism to editorial imagery and, only to a slightly lesser degree, commercial photography. Highly polished styling implies fake, and food consumers are looking for what is real. Surfaces are well worn and shabby, tableware shows a deep patina, and lighting feels like early morning on the farm.

Of course, since trends come and go, following fleeting changes in fashion too closely means that your work may date itself before its time. Where food styling and photography go in the next 10 or 20 years is anyone's guess, but natural-looking food with natural lighting are likely to be with us for some time to come.

1970s © John Foxx

1980s © whitewish

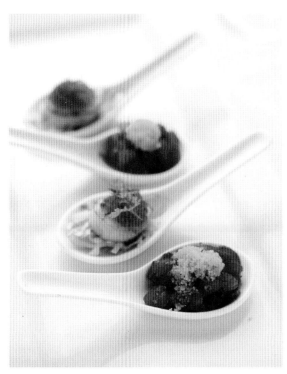

1990s: White on white © Michael Kennedy Photography

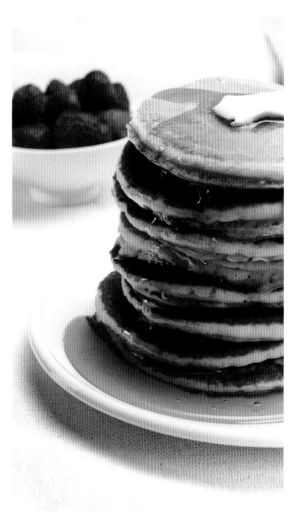

2000s: Natural food © Stuart Burford

2000s: Soft focus © Andy Robinson

15

The team

Every shoot needs a client, an art director, designer(s), stylist(s), and, of course, a photographer. However, the number of people playing those roles may vary greatly from a single person covering every role (in the case of a food blogger) to many people working together to achieve their responsibilities. The number of people involved will depend on the complexity of the shoot, the importance of the final product, and the time needed to produce the shoot. One person can accomplish all of these roles, but it will certainly take a lot longer. On the flip side, a team of 20 people can be almost as challenging to manage!

Stylists at work

Client

Food photography clients range from restaurateurs to food producers and publishing houses, so their knowledge of photography will vary greatly. A client's primary role is to provide the required shot list as well as any recipes/products that are to be included, and then to give final approval of the work. Some clients will want to attend the shoot, but most will have a representative there with the authority to approve shots.

Art director/designer

The art director guides the look and "feel" of the shots, including composition, layout, color requirements, and any technical requirements for the delivery of the images. The art director/designer may also take on the role of location and/or talent scout if necessary. The art director/designer is often the liaison for the client, although in the case of publishing or advertising firms, the art director may also be the client.

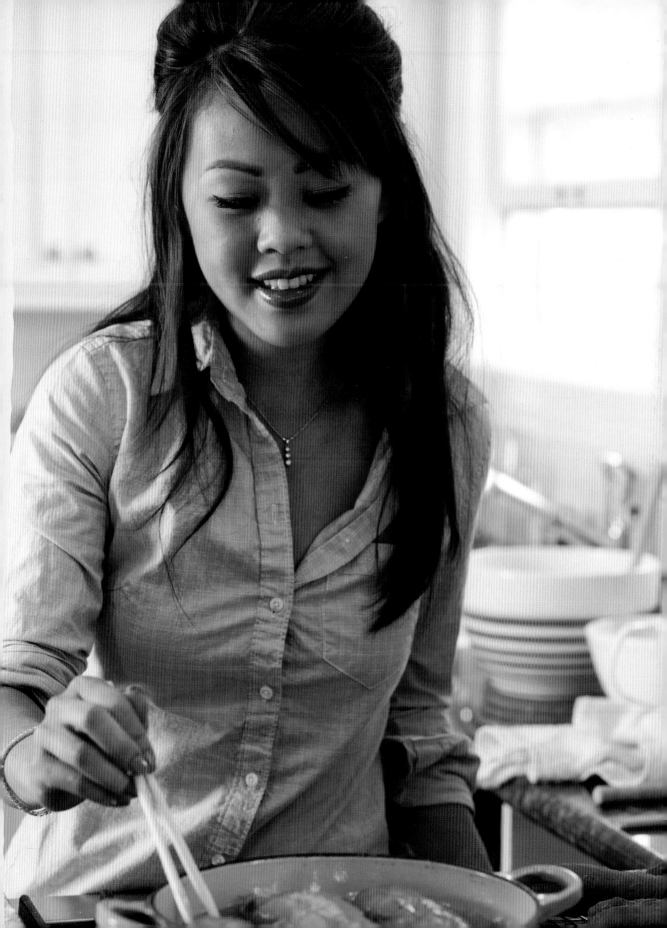

Photographer

In addition to the obvious requirement of taking the images, the photographer is also responsible for all lighting setups and the camera gear, as well as post-processing the images, providing final artwork, and archiving clients' images. The photographer is also usually responsible for providing studio space, and can also be asked to scout locations and talent, and to hire the food and prop stylists.

Most photographers work with assistants, who do everything from helping with the lighting to running out for coffees and sandwiches.

Food stylist

The food stylist prepares the food for the shoot—whether that is making a recipe from scratch, plating a premade product, or even building a sculpture from food. The food stylist (or assistant) is responsible for buying all ingredients, providing any tools or equipment needed to prepare the food, and cleaning up afterward. Food stylists must also have a good eye for detail, picking out the best-looking products from a large selection, as well as the ability to adapt recipes to the needs of the shoot.

The food stylist is also typically responsible for any on-set adjustments to the food, including small changes in positioning.

Prop stylist

Although many shoots combine the roles of food and prop stylists in one, they are in fact two different skill sets involving different responsibilities. The prop stylist is in some ways the designer of the shoot, arranging all nonfood items on the set—from the shooting surface to the backdrop to the tableware. Selection and variety are important, and the prop stylist must be able to provide options that work best for the food, lighting, and style needed. Prop stylists will bring not just one bowl or a dish, but many choices to work with.

On some shoots the prop stylist may provide just the props, leaving it to the food stylist and art director to place everything in position. In most cases, however, the prop stylist will arrange the set and work in conjunction with the food stylist to set up and adjust the props as necessary.

Starting to plate

A day in the life

Just as there is not a set number of people on a shoot, there really isn't a single easy description of a day in the life of a food photography shoot. One of the joys of the job is that there are always new challenges to solve, and different photographers and stylists will come up with completely different solutions to the daily puzzle. (See the case studies in Section 4 to see just how different shoots can be.) However, there are still a few general steps that will help a shoot be successful.

1. Planning

Any photo shoot starts with a review of the shots. On larger-budget assignments, this planning is typically done at a preproduction meeting, where the photographer, stylists, and, if it's a separate role, the art director will all get together. The meeting may also include the client and designer. On smaller shoots, this meeting could be replaced by a series of emails intended to define the shoot requirement, including such things as:

- Where the shoot will take place and who will be involved
- Recipes and/or products to be shot
- Example photographs that depict the lighting and propping styles
- Layouts indicating the crop and space needed for overlays and illustrations

2. Scheduling

The photographer/stylists work to develop a shoot and shopping schedule based on the product requirements. Considerations could include:

- Related recipes or recipes using similar ingredients to be scheduled back to back to minimize costs and time
- Shorter and simpler recipes to be interspersed between longer lead-time recipes to keep the set busy
- Products with shorter life spans to be scheduled earlier in the day to shoot them at their freshest

But a good shoot schedule will always allow room for complications along the way.

Once the schedule is understood, the photographer can then begin to plan the lighting for the shoot. This will be done either at a general level—such as, natural, bright daylight-looking, intimate evening setting—or on a more detailed, shot-by-shot basis—for example, sidelight from the right, with a highlight on the product—if specific layouts have already been provided.

3. Shopping

The food stylists and prop stylists (or their assistants) are typically responsible for all the shopping related to a photo shoot, including buying the surfaces, tableware, and ingredients. The stylists must work to a specified budget, and they are often responsible for paying any out-of-pocket expenses, which are reimbursed at the end of the shoot. For large shoots, however, a stylist may request an upfront deposit to cover these expenses.

The food stylist prepares a shopping list of the recipe ingredients or products needed, as well as a list of styling equipment needed for the shoot. The shopping may be done for everything all at once, or it can divided between different shoot days to ensure the freshest-looking ingredients. The food stylist must make sure that there is enough product for the shoot to get the best-looking hero (see below), as well as allow for any reshoots. This usually means buying three to four times the quantities required by each recipe.

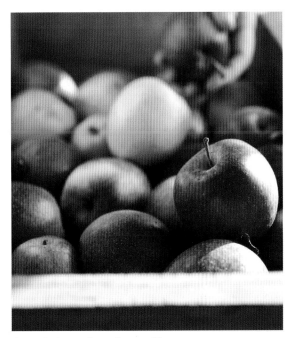

Choose the best quality products possible.

The best ingredients make the most beautiful food.

Prop Choice

The prop selection must contain a variety of sizes, shapes, and variation of colors to ensure the shoot runs smoothly. Often, props are reviewed several days before a shoot to narrow down specifics and allow time to pick up any additional items. For example, the art director may review 10 different styles of wine glasses, approve two or three of them, and have the prop stylist pick up a full set of each of the styles.

Prop stylists may provide props from their own collection or rent them from prop houses. Most prop stylists also have relationships with local retailers, and may "rent" or borrow anything from furniture to linens from stores for a small fee if they are returned with no damage. Or the fee could be waived in return for a credit in the publication. In these cases, products must remain in salable condition (tags are tucked away for shots rather than removed), and detailed lists have to be kept to ensure that products are returned appropriately.

4. Prepping

For the photographer, setup includes making sure that all the photographic and lighting equipment is available and in perfect working order. Batteries are charged, lights are checked, disk space (or, less frequently these days, film) is plentiful and ready to go. For most commercial food pictures, photographers shoot tethered to a computer—both on location and in the studio—so that each shot can be immediately approved or rejected. This is often true of finished-dish editorial photos, such as for cookbooks or magazines.

For the stylists, prep work likely begins before the day of the shoot. Like a restaurant kitchen, much of the food-styling work is done the day before the actual shoot. Ingredients are cleaned, chopped, par-cooked, and stored in a way that allows them to be quickly assembled on the day of the shoot.

For the prop stylist, prepping consists of organizing the dishware and linen options by shot for quick access, and carefully cleaning or pressing each piece. Glassware in particular needs to be smudge-, dust-, and fingerprint-free. For extreme close-ups, prop stylists may even choose to handle the tableware with gloves to avoid marks.

Portion size

Careful attention to portion size is particularly important for any images that are associated with food nutrition data, such as packaging, some advertising, and some recipes. Images should show either a single serving size or the whole recipe or product (or at least imply the whole product) to avoid giving the impression that the consumer may eat more than the nutritional guidelines imply.

Portioning goes beyond the size of the muffin or slice of pie. Stylists also need to be aware of how many chunks of chicken or slices of carrot are floating in the soup or the ratio of fruit to nuts in the trail mix.

5. Propping

Once the lighting is roughly agreed, the prop stylist will begin to build the set, usually in conjunction with the photographer (or assistants), starting with the background and shooting surface. Linens and tableware will be placed, typically without any food, to allow the photographer to set up and refine the lighting. Test shots will be fired to ensure that the props work well together and with the lighting. Placeholder food may be included once the set is close to completion to refine the lighting further. In this case, it is particularly useful to have more than one of each piece of tableware. Then the "hero" food (see right) can be plated without requiring the washing of a dish.

The prop table

6. The hero

The hero is the final preparation of the food intended for the finished photograph. The hero appears when the camera position and lighting have been decided. At this point, the food stylist is typically the only person "touching" the set. Only small refinements are made at this point. Cheese may be melted (or refreshed), last-minute herb garnishes added or swapped in, oil brushed on, or glasses of beer topped off to create a foamy head. Then the photograph is quickly taken.

Once everyone has approved the shot, a few alternative pictures will be taken—a quick change of depth of field, exposure, shooting angle, or even lighting. From the styling side, more sauce may be added, drips exaggerated, props added or removed, or backgrounds changed. Despite careful planning, sometimes the best images come from these less-controlled shots.

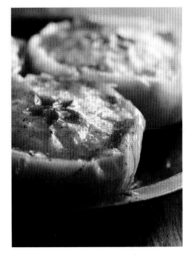

The hero

The proofs

7. Clean-up

Most food shoots result in a lot of leftover food—some edible, some not. Unopened packaged food may be donated to food banks, but any opened leftovers should be discarded. Because the goal of a food shoot is the image, not the taste, safe food-handling requirements are usually not followed. So taking food from the set is rarely a good idea. Instead, it is safer to compost any leftovers that have been questionably prepared or stored during the day or days leading up to the shoot.

2. PHOTOGRAPHY & LIGHTING FUNDAMENTALS

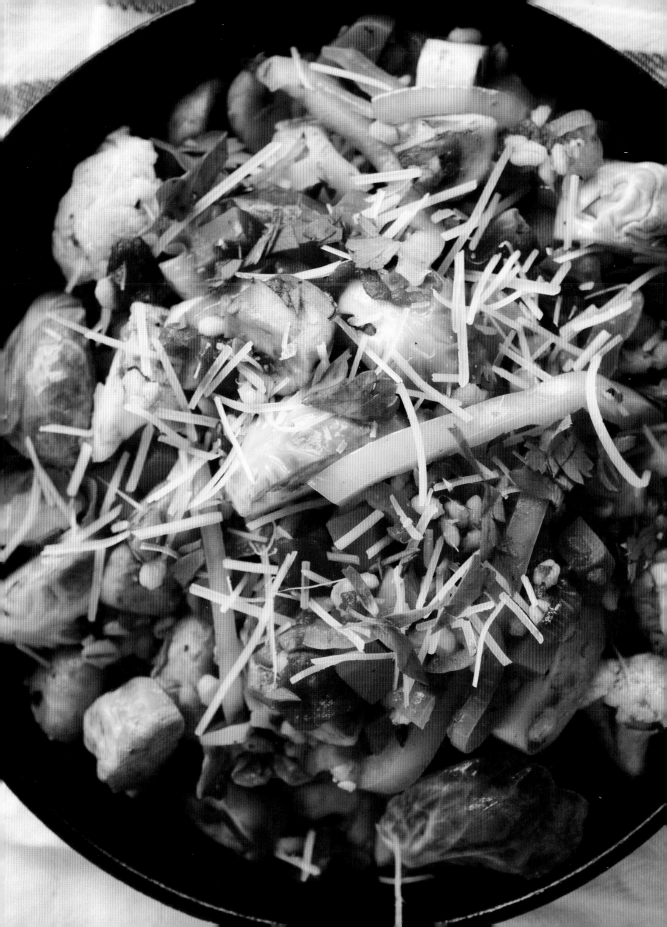

Photography equipment

It all starts with the gear, right? Certainly "What are you shooting with?" is one of the first questions any photographer is asked. Having the right equipment certainly doesn't guarantee a great photograph, but it does help you along the way.

Camera bodies

Traditionally, food photographers—in common with most other studio photographers—have used medium-format cameras. However, with the advent of high-end digital SLR models, medium format is becoming less commonly seen. Even for web and video work, it is not unusual to see digital cameras with smaller sensors being used for food photography. There is also a trend toward using vintage film cameras for lifestyle photography, including food photography. Polaroid film, while no longer in production by Polaroid, is particularly popular for this.

Lenses

Because the needs and styles of food photography vary considerably, there is no ideal "food photography lens." However, there are a few lenses that are more commonly found in a typical food photographer's bag. Regardless of the lens, to create the soft "bokeh," or blur, that helps to highlight the food and not the busy background, look for fast lenses with maximum apertures of f/2.8 or larger.

Macro lenses

Lenses with a minimal focal distance, usually less than 12in (30cm), are known as "macro" lenses, and allow for the tight shots often found in today's food magazines and cookbooks, and, a little less frequently, in commercial work. The typical lens focal length is 100mm—with a moderate telephoto such as this, the photographer can reproduce the food larger than life when taken at close range. In these images (what one would typically think of as "food porn"), all the context of the food falls away and the viewer is left with the intensity of a single aspect of the subject.

Wider lenses, such as 60mm, can also be macro in their focusing ability. These lenses still allow the photographer to get in very close, but do not magnify the subject as much as a telephoto would, giving more overall perspective to the dish.

Good-quality lenses of the type described above include:
- Telephoto macro lenses: Canon 100mm f/2.8 macro, Nikkor 105mm f/2.8 macro.
- Standard macro lenses: Canon 50mm f/2.5 macro, Canon 60mm f/2.8 macro (EF-S), Nikkor 60mm f/2.8 micro.

Focal length 100mm *Focal length 70mm* *Focal length 50mm*

Standard lenses

When photographing food in its full environment, or the people who work with the food, using a standard or wide-angle lens will help you capture more of the context of the image, or allow you to record an entire buffet table full of food without having to stand at the opposite side of the building. Look for standard and wide-angle lenses that allow you to focus as close as possible, as this will allow you to get close to the food when necessary.

Good choices include:
• Canon 50mm f/1.4 or f/1.8, Nikkor 50mm f/1.4D.

For the greatest flexibility, in the studio and on location, look for zooms that go from wide-angle to telephoto without trading off too much in terms of aperture:
• Canon 24–70mm f/2.8, Canon 24–105mm f/4, Nikkor 27–70mm f/2.8, Nikkor 24–120mm f/4.

Zoom lenses

In general, most studio photographers shoot with fixed focal length, or prime, lenses. The quality of the glass that you get with a prime lens for the same price as a zoom outweighs the instant cropping and framing advantages provided by a zoom. However, when shooting on location—particularly when capturing candid or real-life subjects—the need to focus in quickly on a subject or broaden the composition warrants the inclusion of a zoom.

Sensor size
Be aware that lenses designed specifically for digital camera bodies with APS-sized sensors will not work when upgrading to camera bodies with full-frame sensors.

Specialist lenses and attachments

- Tilt-shift lenses: Canon 90mm f/2.8, Canon 45mm f/2.8, or Nikkor 105mm f/2.8 macro
- Lensbaby® (a lens with a small bellows attached)
- Bellows

Specialty optics, such tilt-shift lenses, Lensbabies®, or lenses attached to bellows allow the plane of focus to be adjusted from the typical angle parallel to the film (or sensor), to the angle of the front edge of the lens. This can be particularly useful in food photography, allowing a shot to highlight a very specific area of the subject while rendering the rest of the image soft—for example, the surface of a bowl of soup sharp, while everything else is blurred.

Lens hoods

Using a lens hood not only helps protect the lens from fingerprints and accidental damage, it can also help to produce richer images by shading the surface of the lens from stray light and unwanted glare, a problem that can occur with side- or backlit images. The main potential drawback with a lens hood is that of vignetting, which can be particularly noticeable in shots taken on a white background if the angle of the lens is too wide for the hood in use. Using a hood designed specifically for the angle of the lens helps minimize this problem—but post-production programs, such as Adobe Lightroom, make it easy to correct.

Tripods and studio stands

Most food photography sessions require the use of a tripod-mounted camera. Editorial photographers capturing environments and lifestyle images, such as trips through markets or on farms, and some editorially styled work where precise composition is not critical, might be shot with a handheld camera. Many food shots, however, are taken in low light. In these circumstances it's critical to use a camera support whenever the shutter speed falls slower than 1 over the lens focal length (for example, a shutter speed 1/100 sec with a 100mm lenses or 1/50 sec with a 50mm lens). This advice holds true even when using image-stabilized lenses.

Original setup

Fixed position

Camera supports are not only used when light levels are low. There's a difference between capturing an image and creating one, and much food photography is about the latter. As you work on a shot, small refinements are inevitable: a strawberry is moved here; a napkin shifted there; cheese is remelted; background colors are changed. If the camera is constantly moving, even by the smallest amount, the crucial shot could well be ruined.

Once the basic shot was set up, several small changes could easily be made without worrying about changing the overall composition.

The teacups were removed for this shot.

The teacups were replaced for this shot.

The spoon was removed from the honey pot for this shot.

Basic requirements

Your choice of a tripod or studio stand is largely subjective and is dependent on the type of work you do. The weight of the tripod is typically unimportant—few food shoots require hiking up mountain passes with a tripod strapped to your back—but stability and adjustability are critical. A good studio or location tripod needs to be stable on a wide range of surfaces, and ideally it should include a built-in level. The tripod should have an adjustable center post—to allow for quick, fine adjustments to camera height—as well as legs that you can lock into a variety of angles. It's a bonus if the center post rotates to a horizontal position to provide camera support for top-down shots. Minimum and maximum camera heights should also be considered based on your style of work.

For even greater stability and precision, studio stands are often used for high-end food and product photography. Studio stands allow for overhead shots, where you can position a camera at a height above 6ft (1.8m), which would be impossible with a tripod. Their heavy weight also eliminates most camera shake and there's little chance of the stand tipping over, no matter how heavy the camera and lens attached to it.

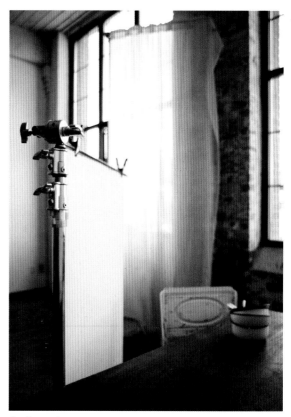

Studio stand

Tripod heads

Tripod heads allow for quick or precise (rarely both) movement of the camera on the tripod. The classic tripod head is a three-way pan-and-tilt head, which has different levers for each movement: tilting up or down, panning left to right, and tilting side to side. With separate movements, there is more futzing to find the exact angle to shoot but, once there, it is simple to fine-tune framing in a single dimension.

Ball heads are an alternative to the three-way pan-and-tilt head. These allow the camera to be positioned at almost any angle, quickly tilting front to back and side to side at the same time, with a separate mechanism for panning. While ball

Clamps

heads allow for very flexible positioning, they can be difficult to control precisely in one dimension without moving in another. It's worth renting both before committing to a ball-head style to find out what works best for you.

Geared tripod heads provide both precise control and ease of adjustment—but at a price tag that is three times that of a high-end ball head. A geared head has two separate panning mechanisms with a hinged base geared movement for other adjustments.

Finally, to add a higher degree of precision to tabletop work, a focusing rail system allows you to make small camera movements closer and farther away from the subject without adjusting the position of the tripod's legs.

Tripod head

Other tools

Most photographers have their own secret stash of specialized accessories they've found invaluable over the years, but here are a few for you to consider.

A small surface level helps to ensure that shots, particularly those shot top-down, are not running up- or downhill. Pocket levels can be bought at most hardware stores, but camera stores may have small levels that fit into your camera's hot shoe. Smart-phone users can download an app that will turn their phones into great surface levels.

Articulated arms, such as gooseneck stands, with clamps are ideal for holding small fill cards in position or for dangling props. Heftier versions are also useful to have on hand to hold floating forks or spoons in place in front of the camera.

C-stands are always good to have on hand for supporting backgrounds, as well as fill cards.

Almost all studio photographers these days shoot tethered to a computer with a USB cable. Shooting tethered allows the photographer to instantly confirm exposure and focus to ensure the shots are what the client needs. Software such as Phase One's Capture One or software that comes along with most digital cameras also allows for complete control over the camera settings without touching, and potentially moving, the camera.

Lighting basics

Front lit with natural light

If you take just one thing away from this book, it should be that lighting makes great photographs. This is particularly true in food photography. The most beautiful plate of food will look dismal and unappetizing if poorly lit, while the ugliest dish can be elevated to an art form with the application of the right lighting. Achieving the best lighting is a matter of its quality and the angle at which it reaches the subject.

1. The key light

This light defines the principal shape of the subject. For food shots, you usually want to bring out the shape and texture of the food by creating subtle contrasts of light and dark, shadows and highlights. The position of the key light is the most critical aspect of such an image. The key light can come from the side, back, or front of the subject, and it can also vary in height.

2. Frontlighting

Soft frontlighting may be suitable for portraits of people because it has a smoothing, flattering effect on skin tones; in food photography, however, it has a flattening effect on the subject and so is not often used these days. It is best not to use on-camera flash for images of food unless you are trying to replicate food images of the 1960s and 1970s.

3. Sidelighting

Light coming front the side, and typically slightly behind the subject, is commonly used in food photography because it creates beautiful high- and lowlights, enveloping the food in light and shade in order to enhance its shape. By narrowing the focus of the light so that it falls on the subject alone, you can easily create moody shots with dark backgrounds. Widening the light so that it spills past the subject and onto the background produces more of a bright, airy, and evenly lit photograph in which, if you're lucky, the subject simply "pops."

4. Backlighting

Light from the rear can produce a beautiful rim of highlight on the subject, similar to a hairlight in a portrait photograph. However, unless you want to wash out the subject and completely blow the background, then you will need to take care when using this lighting technique. A very diffused backlight with a strong front or side fill will help minimize any loss of detail. Shooting from a slightly higher angle also minimizes the chance of blow out as the light will not be shining so directly into the camera lens.

Side lit with natural light

Backlit with natural light

High side light with flash

5. High lights or low lights

The vertical position of the key light plays an important role on how the highlights and shadows in a shot work. When the light is high, shadows will be short and close to the subject, and the top surface of the subject will be very bright. Lower lights create drawn-out shadows, and minimize surface glare, and create a softer more natural look, as though the subject were positioned by a window.

6. Altering the light

The contrast between the light and shadows sets the mood of a shot. Once the key light is established, secondary light sources, or fills, are positioned to open up shadows or provide highlights. The fill light may or may not be a physical light source. For most food shots, a fill is simply some sort of reflector card that bounces a small amount of light back onto the subject. It may be a white, silver, or gold reflector, a mirror, or even a formed piece of aluminum foil.

Low side light with flash

Sometimes blocking light is just as important as letting it in. If light is hitting the background and the subject equally, the overall shot may be too bright. Dark, even black, backgrounds can appear a light gray when highly lit. By blocking light to the background with a curtain or piece of black card, you can refocus the attention on the subject. If you need to subtly change one of the light sources, simply place a silk, Scrim Jim (a silk with a frame), or even some translucent vellum between the light source and subject to reduce the light as much as a stop or two, as well as to diffuse it over a broader area.

Natural light

Talk to most food photographers about their preferred lighting style and you might hear much the same thing—an endless gush about the beauty of natural light. There is just something about natural sunlight that makes food look tantalizingly delicious. Most likely, this is because we typically see food at its best in natural lighting. When we think of good food, we imagine a pie on a window sill, buckets of apples at a farmers' market, or a picnic in the park.

Of course, it isn't as simple as flopping a plate of food down next to a window and grabbing the camera. Do that, and you are likely to end up with harsh shadows or camera shake. Natural light, like any other type of lighting, needs thoughtful modification to achieve that buttery quality that is so sought after by art directors and clients.

As with any light source, it is critical to start by planning the direction of the light and how it falls on and illuminates the food. Find the largest windows you can at the level of your shooting surface. It's important that the window is not too far above the subject. As you will want to be able to light the entire dish, the ideal "window" for shooting is actually a garage door, which you can lower slightly to block off early afternoon sun.

If the sun is visible through the window, you can soften its quality by using a silk, thin sheer, white drape or a length of vellum paper. On cloudy days, or if the window is illuminated by indirect light (north-facing windows in the northern hemisphere and south-facing windows in the southern hemisphere), this shouldn't be necessary.

Position your shooting surface with the window to its side or slightly behind. The table doesn't need to be pushed right against the window—it's better to leave a bit of room to allow for moving around.

Typically, indoor natural light shots will have a single light source, and so you will need to introduce some fill in order to bring out the detail. A large white card or Scrim Jim, ideally one that is 6 x 6 feet (1.8 x 1.8 m), placed opposite the window, will give broad, soft light to the shadow side of your hero, keeping the light looking natural. Smaller cards and mirrors, placed closer to the subject, can be used to highlight additional details, such as giving a tomato a little extra glint or bringing out the texture in a slice of bread.

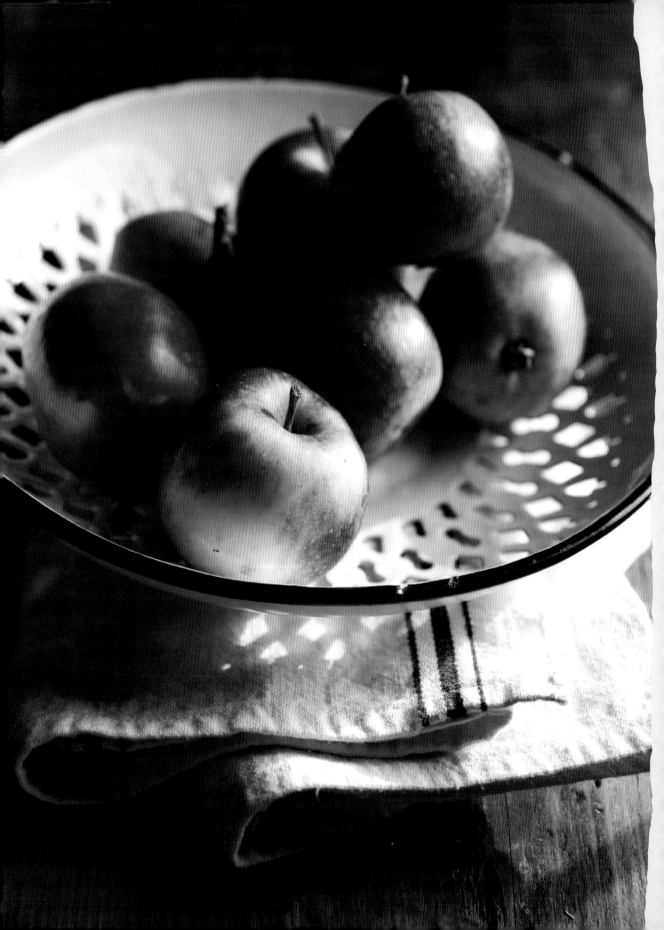

To shape the light coming in, get creative about what you place between the subject and the window. If a particular highlight is too strong, use masking tape (or even a piece of self-adhesive notepaper) on the window to "flag" off the light and soften it. Bottles placed between the window and subject can refract the light to create interesting lighting shapes, and these can be less controlled and real looking. A crocheted linen hung over the window can create a beautiful dappled effect, as though the table were shaded by an expansive old tree on a bright summer's day.

As much of a joy as it may be to work with natural light, it also means surrendering a considerable amount of control. The position, color, and quantity of the light will change over the course of the day, requiring the shooting angle and position to be changed to maintain consistency. In many cases, for long shoot days, sadly it is more trouble than it is worth.

Even over a short shoot, changing lighting conditions are a typical concern. When shooting with natural light on a partly cloudy day, you may find it much simpler to shoot in aperture-priority mode with exposure compensation rather than setting the camera purely to manual. Then, when those fluffy little clouds go by, you won't have to worry so much about your shutter speed when shooting.

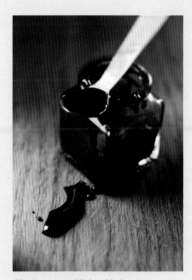

Shaping natural light adds drama.

A variety of cards or objects can be used to shape natural light.

Artificial light

Shooting with natural light does have its disadvantages. When it is good, it is very, very good, but there are times you simply cannot get the light you need to achieve the shot you require. Because of this, most studio food photographers use a selection of strobe units with attachments such as soft boxes, umbrellas, grids, and snoots to carefully control and shape the light.

Shooting for editorial

Editorial images are quite often shot with a single, large light source that mimics natural daylight from a window. Typically, this is a strobe fitted with a large soft box, placed to the side and a little behind and above the subject. An alternative setup could be a strobe angled so that its light bounces back onto the subject from a flat wall or corner. Soft, sometimes dramatic shadows can be created to enhance the mood of the shot. Another trick is to shoot with one or two strobes behind a large piece of vellum, milky plexiglass, or a silk, to create a single large diffused light source without the hassle of a setting up a soft box. This diffusion is important not only to create soft shadows, but also to stop down the amount of light from the strobes, which are likely to be too powerful for the aperture needed for shots that require a shallow depth of field. Wrapping the strobe in one or even two sheets of vellum can also reduce the light, but with slightly less diffusion.

With these single-light setups, photographers usually use the same bounce techniques employed with natural light to fill out the shadows.

Shallots photographed with a vellum diffused strobe

Soft box flash mimicking window light

Using a flash to stop the action

Shooting for commercial

Commercial pictures may also be shot with a simple one-light setup, but more usually multiple soft lights are employed, as well as small spots or mirrors to highlight specific aspects of the food or to create separation between the various elements of the subject. Shadows are typically kept to a minimum for packaging shots and may require additional lights for fill.

Using flash to stop the action

At some point, you'll almost certainly be asked to catch the perfect splash or drip moment. While you can use any light source if your shutter speed is fast enough, a short, powerful burst of flash makes this much simpler. Using a shutter speed fast enough to tune out any ambient light, somewhere around 1/200, your flash will pop the subject into crisp light and should easily stop most pours, splashes, and drips.

Video

While strobes are most common for studio stills work, shooting video requires continuous lighting. In the past, this often meant hot lights, such as traditional tungsten or metal halide iodide (HMI), which quickly wilted any food they illuminated. However, recent improvements in fluorescent and LED lights have been a boon to food photographers.

Fluorescent light banks are relatively lightweight and offer flicker-free, color-corrected light that draws little power, making them a good choice for both studio and location work. Fluorescent light banks also create a soft, even illumination and produce very little heat output—perfect for most food shoots.

Like fluorescents, LED video lights provide lightweight, bright, but soft, illumination with very little power usage or heat output, albeit at a slightly higher price point. Some LED lights are also small enough to throw into a camera bag, which makes them great for impromptu restaurant shots.

Location lighting

Location lighting follows the same rules as studio lighting, but there are a few key requirements, such as portability, to keep in mind.

Indoor locations

Most indoor location food shots are either finished-dish or product shots, or atmospheric shots involving someone preparing or delivering food. If you have an opportunity, try to scout the location ahead of time not only to judge the lighting needs, but also to confirm with the proprietor your expectations of the amount of space required for the shoot.

Natural light

To illuminate finished-dish shots look for natural sunlight options wherever possible. Seek out a window letting in indirect light (north-facing in the northern hemisphere, south-facing in the southern), and set up your table with the window to the side or slightly behind. If the light coming in through the window is too strong, diffuse it with a translucent drape or a piece of vellum.

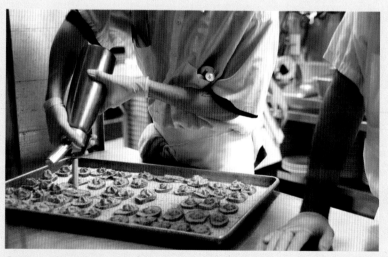

Restaurant kitchen light can be beautiful if you find the right angles.

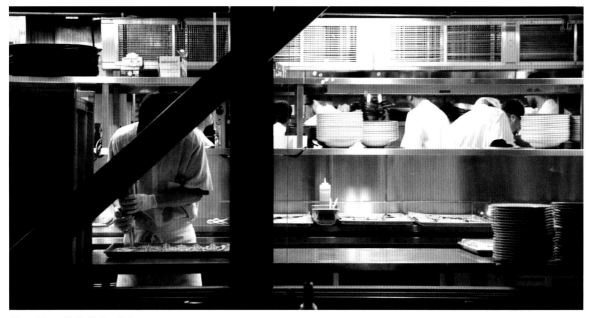

Shot with available kitchen light

Improvisation

If no windows are available, you can improvise with a doorway or even by positioning the table outside. Just make sure to diffuse over-strong sunlight to avoid harsh shadows. You can even position a shoot-through umbrella, which is usually used to diffuse studio flash, between the dish and the sun as a last resort. Just as you would in the studio, bring along a couple of reflectors to open up the unlit side of the dish.

Battery power

Forget bulky lights that require main power outlets (often a challenge in restaurants) and soft boxes that take time to set up and adjust, and instead opt for simpler battery-operated shoe-mount flashes. One or two remotely triggered speedlights, mounted on lightweight collapsible light stands, and diffused with shoot-through or reflective umbrellas, pack up quickly and provide plenty of natural-looking light.

Artificial light

Of course, there are always going to be situations where no natural light is available—shooting in a restaurant kitchen, shooting at night, or shooting in a backroom of a warehouse are all common situations for food photographers to find themselves in—and then you'll need to break out your lighting equipment.

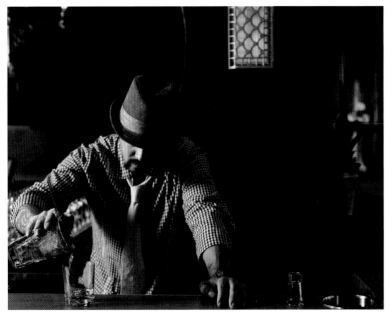

Shot with two diffused speedlights, one on each side, for a dramatic look

Warm or cold

Be aware that any overhead lighting used in a shot may be incandescent (warm in tone) or fluorescent (cold in tone). If you are using flash with the maximum shutter speed, these overhead lights aren't too much of a worry, since the flash will overpower them. However, if you are using natural light as your primary light source, turn the overhead lights off to avoid unwanted color casts and highlights.

Appropriate lighting

Food shots in restaurants need to reflect the time of day the meal will be eaten, not the time of day you are shooting. Breakfast and lunch foods usually need brighter settings, so use some backlighting or ensure that light is falling on the background. For dinners or cocktail shots, aim for a moodier, dark background by blocking light from falling behind the hero with a drape, a black card or flag (a small piece of fabric or paper that blocks light).

When capturing action shots, such as in a kitchen or busy dining room during business hours, adding lighting to the scene may not be an option. In these situations, it is critical to use a fast lens, wide open, and a high ISO in order to capture the scene. An on-camera flash, with the light bounced off the ceiling or a wall, can add just enough light to make your action shots sharp without creating too much of a disturbance. However, avoid using on-camera flash pointing directly at plated food as the results will be flat and unappealing.

Outdoor locations

Outdoor location food shoots are usually lifestyle shoots involving people as well as food, and so require the typical type of portrait lighting techniques you are probably used to. Picnics, markets, cafés, and farms are all common outdoor locations for this type of shoot.

Dealing with daylight

Natural light is often sufficient for these shots, but it is best to shoot on a slightly overcast day if possible, when the clouds will act as a natural soft box, or shoot in the early morning or late afternoon (three hours after sunrise or three hours before sunset). If you have to shoot at midday on a sunny day, go undercover. A leafy tree, an overhanging rock, a bridge, or doorway—any of these will keep the harsh overhead sunlight from reaching your subject too directly, but then be careful of color casts.

Afternoon light at the vineyard

If you are stuck shooting at midday with no cover, try using an indoor portable flash system (see page 43) to counteract harsh overhead sunlight to provide a softer, more directional light. Just as you would indoors, position the flash, diffused with an umbrella, to the side and slightly behind the subject, and use a reflector to lighten any shadows on the opposite side.

For a stronger, brighter look, you can also use your diffused flash as a fill light, and the full power of the sun as your key light. You'll still have strong, tight shadows, but you will be able to maintain the detail by slightly minimizing the contrast.

A cloudy day at the farmers' market

Midwinter day in the wheat field

Forest fires nearby created interesting light at sunset in this wheat field.

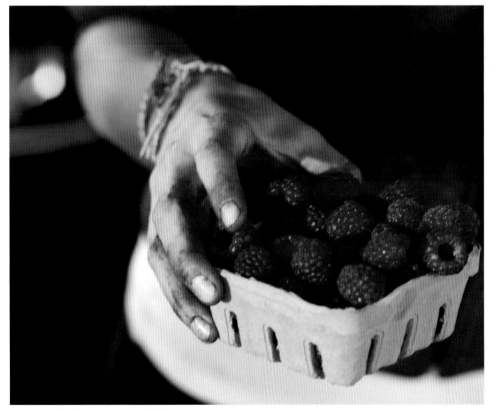

Raspberries shot in strong summer light

Composition

In addition to establishing the lighting, the photographer and art director are responsible for the composition of the shot.

Camera angles

There are three traditional camera angles used for food photography: the diner, top down, and straight on.

Diner's angle

The diner's angle, sometimes called three quarters, isn't an exact angle. It is simply a position somewhere slightly above the subject looking down, typically at an angle of between 20 and 55°, as you would see a plate of food in front of you if you were sitting at a table to eat. The diner's angle brings a certain sense of immediacy to the food, and invites the viewer to "dive in." The lower the camera angle, the more depth the photograph has, which often means that more background propping is involved.

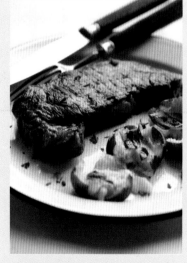

Diner's angle

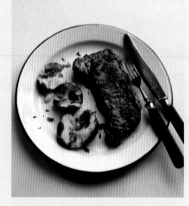

Top down

Shooting from a slightly higher angle means that you no longer need worry about the backdrop, but be careful not to shoot from too high an angle (above 70°), or the dish may appear to be sliding down the table.

Top down

Top-down shots—in other words, shooting directly above the subject looking down—are highly graphic, and are often used for ingredient component shots, such as the key ingredients included in a dish. Because the image is shot top down, there is usually little depth to the resulting image, which creates a more graphic look.

It's important to level your camera for these shots as a subtle tilt to the camera will look "off." If you have an iPhone or Android phone, check out the Surface Level app.

Straight on

Straight-on images—those taken with the camera parallel to the subject—are best for dishes where you want to emphasize a subject's height, such as sandwiches, tiered desserts, or pulled-back full-table shots. These shots are also often more graphic in nature, in which the depth of the subject is less important than its height.

Straight on

Wide and tight shots

Wide shots—ones showing a whole dish or even a whole table—set the overall context for a story, be it a party, an intimate diner for two, or a farmer's market stall. The subject food becomes a single character in the overall tale. But often the challenge with wide shots is to keep the food item as the recognizable focus of attention when, typically, the food item is small compared with the rest of the scene.

Tight shots can suffer just as badly from the opposite problem—by getting in close, the smallest details are amplified, often bringing out aspects of a dish the viewer does not normally experience. This can create a beautiful image, or it can leave the viewer wondering what they are seeing and why they are seeing it.

Always check the minimal focal length of the lens you are using when shooting a close-up, or the end result may be subtly blurred. A macro lens—such as a 100mm f/2.8—will give you the greatest flexibility for tightly framed "beauty" shots.

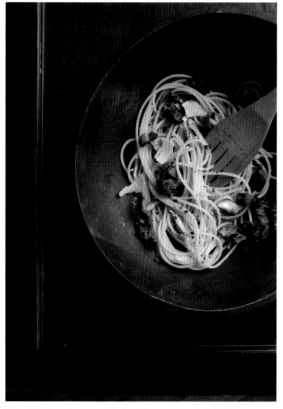

The wide shot of pasta emphasizes the warm mood of the dish.

The tight shot focuses on the elegant shapes of the pasta.

While you may need to shoot to a specific layout, it is always a good idea to grab both wide and tight shots to give your client different options. Start with the shot the client has requested, but shoot any close-ups as soon as you can to avoid any drying, gelling, or wilting of the food, all of which become more pronounced the closer in you shoot.

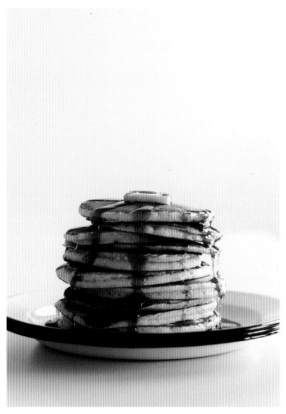

The wide shot of pancakes showcases the stack.

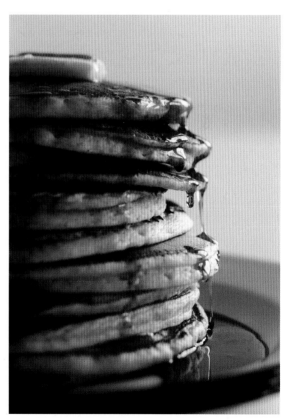

The tight shot of the pancakes is all about the syrup.

Orientation and cropping

Portrait-oriented food shots, which are typically used for magazine or book work due to their shape, usually have greater depth than their horizontally, or landscape-, oriented counterparts. It's simpler to show more foreground and background in a portrait-oriented image.

When shooting for web or email use, clients usually require landscape-oriented shots, since these better fit the shape of the screen. Landscape-shaped images may also be required for magazines for double-page spreads.

To get more depth from a landscape shot, place the hero to one side of the image, and imagine a diagonal line running from the subject back into the image to an imagined far corner, as if the image were the front face of a rectangular box. Then add supporting props behind the hero in that space, or leave it blank for text.

Regardless of orientation, aim for a composition that doesn't bullseye the subject by placing it directly in the middle of the shot or bump it up too closely to the edge of the frame. The rule of thirds suggests that you imagine a grid of two vertical and two horizontal lines placed evenly over the image, dividing the space into thirds both vertically and horizontally. The ideal position for the subject is at the intersection of those lines. While it is fine to break this rule, it's a good starting point for any shot.

Packaging and some advertising shots don't always require a specific orientation, but may require significant white space around the image to allow for cut-outs or cropping.

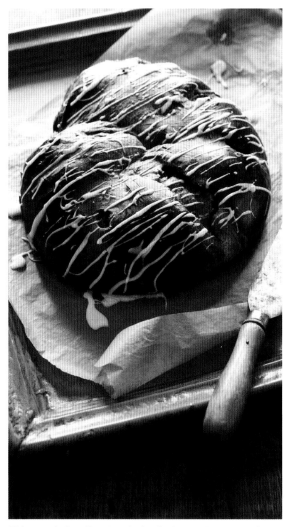

This portrait shot of bread emphasizes its shape and leaves lots of room for copy.

The landscape shot of bread achieves depth by taking advantage of the diagonal lines.

When shooting artistically, most photographers will attempt to shoot to a crop in the camera. However, when shooting commercially, it's important to allow for flexibility in how the image is to be used. Most designers will require the ability to crop, at a minimum for bleeds and trims, but also for artistic purposes. For most commercial uses, an image should be composed to allow for at least 1/2 inch (12 mm) of cropping on all sides without impacting the subject.

It's also a good idea to compose some shots with space for text to be inserted. Even if the shot isn't used this way, having empty space can often make a good shot even stronger.

The portrait shot of the tenderloin focuses more closely on the meat slices without losing depth.

The landscape shot has to pull back to show the same slices, showing more of the whole scene.

Depth of field

The softness or sharpness of an image is a stylistic decision largely influenced by the fashion prevailing at any particular time. In the early days of food photography, images were shot with infinite focus; during the past 20 years, however, food photographs have softened, sometimes to the degree where only the smallest sliver of the subject is rendered sharp. In order to avoid creating images that will become dated quickly, it's best to stick with a moderate depth of field—one that shows the full subject in focus, with the foreground and background elements in a soft bokeh.

Shot at f/2.8

Shot at f/5.6

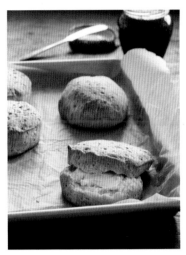

Shot at f/11

Variables

The depth of field is governed by a combination of lens aperture size, lens focal length, and the distance of the subject from the lens. The wider the aperture, the longer the focal length, and the closer the subject, the narrower the depth of field, and the more bokeh there will be.

Specialist lens

Tilt shift lenses also allow you to control the depth of field by altering the angle of the plane of focus. Tilt up, and the plane skims the surface of the dish; tilt to the side and an angled slice of pie can be sharp along its entire vertical surface.

Sensor

The sensor size also has a passive role in determining the depth of field of an image. You must position a cropped-frame sensor camera farther away from the subject in order to get the same image crop and composition, thus increasing the depth of the plane of focus and creating a sharper background than would be the case had the same image been taken on a full-frame camera.

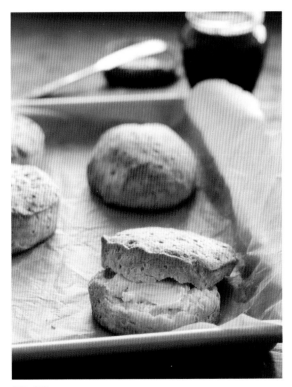

Tilt shift

400 ISO: Little noise

ISO

As a general rule, shoot at the lowest ISO setting the lighting conditions allow. The higher the ISO, the more "noise" an image will have. While 1,600 ISO may be fine, or even a necessity, for some editorial images, most commercial photography applications will require an ISO of 400 or lower. Some stock agencies require an ISO of 100 for all images.

3200 ISO: Very noisy

That little something extra

Being technically skilled is only a part of being a great photographer, no matter what area of photography you specialize in. Successful photographers must also bring something that can't easily be explained to each of their images. It's the combination of the lighting, the composition, and the creative spark the whole team brings that can make one photograph of a plate of pasta look completely different to another.

They say in the recipe-writing community that there are no new recipes. This is equally true of photography—there are no new food images. Name any food, and a quick Internet search will turn up hundreds—perhaps thousands—of pictures of it. Still, like cookbook writers, great food photographers manage to come up with new ways of looking at food and communicating their vision to others.

Understanding the goal of the shot is key to achieving this spark. But it goes beyond this—it is a willingness to play with the subject, to take some risks, and to break some rules. With every shot, ask yourself, what makes this shot interesting? What sets it apart from the hundreds of other shots of the same food? What is it about this shot that is going to catch the viewers' eye and make them stop and look? Great food photographers have that little something extra that pushes their work beyond the mundane, and elevates even the simplest, overly shot foods into images that are truly special.

Post processing

It's always best to get the exposure, color, and composition right in the camera at the time of taking the picture, but most images still do require (or at least can be improved with) a little post processing. By recording images in RAW you preserve the ability to make fairly significant exposure and color corrections with little to no image degradation.

Color correction

You will get the best color correction in the camera by using the custom white balance setting. Take a photograph of a standardized gray card (or, if that isn't available, something you know is neutral in color, such as a white piece of paper), and then follow your camera's instructions to select that image as the baseline for future color correction. Then, all images you take afterward will have accurate color rendition (assuming the light does not change).

For fine-tuning the color in post, most photo-editing software has an eye-dropper tool to select a white object to use as the color baseline. For food images, be aware that many whites aren't really white, but have creamy undertones. By selecting milk for example, you are likely to push the whole image hue slightly too blue. Having a shot with the gray card to use as your color standard helps eliminate any doubt.

Traditionally, editorial food images tend to run to warmer tones, sometimes even with a slight overall yellow cast. However, recent trends have reversed this, with backgrounds and dishes (more so than the food itself) being pushed to cooler, blue tones. Magazines such as *Donna Hay* champion this movement, with at least one feature of food in their trademarked light blue.

When shooting for advertising, achieving accurate color for logos and labels is critical. Because monitor screens can vary, even if regularly calibrated, it is essential to shoot a color card to use as a baseline in the same light as the final shot. Use the color card shot to set the white balance and tone, and then apply those same light settings to the final image.

Monitors—CRT, LCD, and plasma—all need periodic color calibration to continue to display accurate color. Although there are free systems, such as Adobe Gamma (which comes bundled with Photoshop), they rely on subjective measurements that are easily influenced by environmental factors. It's best, therefore, to invest in a hardware color-calibration system, such as those by ColorVision, GretagMacbeth, or ColorEyes.

Auto white balance

Setting a custom white balance with a gray card

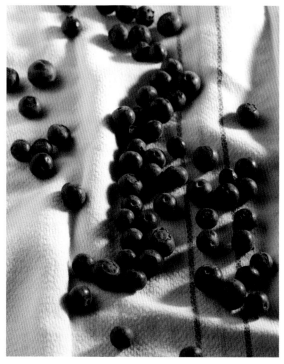

Custom white balance

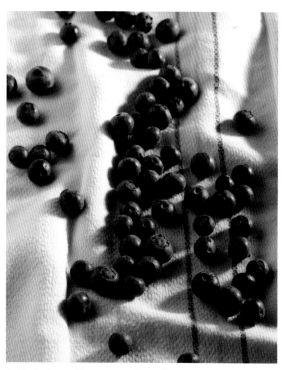

Subjectively tuned in post-processing to give a warmer hue

Exposure correction

Slight exposure adjustments can improve most photographs by adding or taking away contrast. As a general rule—one that can and should be broken often—there should be something black and something white in any given photograph.

The levels tool is the simplest way to adjust the darks and lights throughout an image to boost the contrast and, typically, create a more vibrant look—particularly in scenes without much tonal differentiation. For example, white ice cream arranged in a white bowl on a white background may look washed out with the exposure used to take the picture. By increasing the dark tones a little, the detail of the image will pop without losing the overall brightness of the shot. The contrast will simply make the whites look whiter.

Most levels controls also allow you to adjust the gamma, or the mid tones, in an image, making it easy to add a touch of fill light during post production. While it goes without saying that it is always best to achieve the proper exposure in-camera, adding a little fill light in post production can help avoid the need for an expensive and time-consuming reshoot.

The spot touch up, dodge, and burn tools can be incredibly useful for food photographers. If a particular tomato looked too shaded in the salad, a small touch with the dodge brush can add a little highlight that was absent during the shoot. Burning can take the edge off a small, overblown highlight. Be very careful, however, not to over-correct or the image may start to look unnatural.

As shot

Lights and darks adjusted for added contrast

Layers

Some images simply cannot be achieved using a single shot. Pour shots, for example, shots with drips and splatters, or images that need flexibility of positioning will often be taken as separate images and pieced together in post production to create a single unified image.

When taking a layered shot, it is important to keep the lighting and composition consistent throughout or the image simply will not look realistic when combined. If, for example, you are shooting wine being poured, you could begin by shooting the empty, clean glass to establish the position. This establishment shot means that you no longer have to worry about splashes on the table or splatters on portions of the glass

that should look untouched. Once the glass shot has been established, the light for the "pour" shot must come from the same angle or the highlights and shadows will be wrong. The camera must stay the same distance from the glass, or the "pour" won't fit into the glass. The depth of field must also be consistent or the wine will not have the right softness or sharpness. But the wine pour can be shot over and over until you achieve just the right splash. The two images can then be pieced together in layers to create one coherent and ideal image.

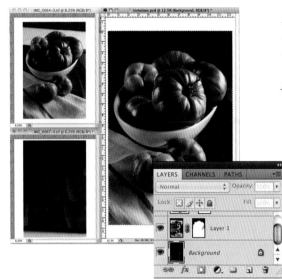

A photo of a wooden board was cloned into this shot using multiple layers. The result was a warmer-feeling image.

Cloning

Even if you've kept the set surgically clean, there are likely to be small blemishes on the resulting images, particularly on macro shots, that need to be corrected. Little pieces of dust (on the food or on the camera sensor) or stray fingerprints or smudges can easily be missed. They are also easy to correct using the cloning brush tool, which "paints," or clones, nearby pixels over the selected area. All food images should be inspected at 100 percent zoom to check for any microscopic specks that, although invisible when viewed at a lower zoom setting, may be apparent when printed.

In addition, cloning is also often used to fill out surfaces. Cloning is very effective on wood tables or solid colored backgrounds.

Although the small speck on this kiwi fruit may not have been noticeable onscreen, in print it would have been distracting. A simple clone makes the image much cleaner.

File formats and output

If possible, shoot in RAW format and keep the files safe and intact. Preserving these original files gives you the greatest flexibility when it comes to their future use.

Images for print

Formatting your images for print is pretty straightforward. Clients should give you the requirements they need, and most will want the highest possible resolution, and request 350ppi or 300ppi TIFF files that are at least 30MB in size. If the client doesn't specify, make sure you ask not only which resolution is required, but also the color profile that is preferred. For print, most clients will opt for Adobe RGB (1998).

A few clients, particularly editorial magazines, may prefer high-resolution JPEG images. Since the images will be a fraction of the size of TIFF files, they are easier to pass over to freelance designers while still providing sufficient resolution for magazine layouts.

Web images

When outputting images for the web, it is important to reduce the size of images greatly to facilitate quick downloading, but not so much that the image quality is unduly compromised. A safe bet for most web usage is an image that fits into a 1,000 x 1,000 pixel square at JPEG compression level of 10; however, it is even better to fit images to the actual sizes required, which will be specified by the client.

Photographs should not be converted to GIFs, which are optimized for line-art type images. Similarly, PNG (portable network graphics) format occasionally compresses an image better than JPEG, but rarely. It's best to keep it simple and just stick with JPEG.

One of the most important aspects of outputting images for the web is the color profile. Web browsers are just beginning to support color profiles, so while your images with Adobe RGB (1998) profiles may look great in Photoshop or even in your finder, the colors—particularly the greens and reds—will look different in different browsers, and that can greatly affect the appeal of food images. To minimize this potential disparity, stick with a more generic color profile, such as sRGB or generic RGB. While these formats will show some color degradation, the consistency is well worth the compromise.

Edits

Regardless of how you are using your images, it is still best to perform edits on copies of original images, save these as TIFFs, and then output alternative versions from them. This ensures that you won't have to make the same edits again if the client ends up requiring higher-resolution imagery.

Sharpening

Typically, there is no need to sharpen your images in post production. If your subject is out of focus in the camera, there is no hope of getting it sharp after the fact. However, if you must sharpen your image, use the unsharp mask filter rather than the standard sharpen filter. Although it sounds like the opposite of sharpening, it actually uses a combination of blur and sharpening algorithms to create the cleanest improvements to edges and the least increase in image noise.

Before trying this filter, however, be sure that you've correctly set your exposure. A clean image with the right contrast probably doesn't need much sharpening to begin with. In Photoshop, you can achieve a bit more contrast by creating a duplicate layer of your image and setting the Layer Blending mode to Hard Light. This will almost certainly be too much contrast, so try reducing the opacity of the layer to between 20 and 30 percent.

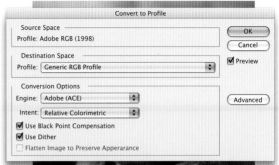

Using a generic RGB or sRGB color profile will help keep colors consistent for photographs used on the web.

Best practices

I am not a lawyer, so please don't take the advice given here as legal counsel. When in doubt, talk to an attorney.

Model and property releases

If your images involve people (even just body parts, such as hands), pets, branded products, or privately owned locations, and you may want to sell those images at any point in the future, then it's a good idea to get signed model and property releases. The purpose of a release is to protect you from any future lawsuits for additional fees, for example, defamation, or invasion of privacy. Releases will also be required for any commercial use of your photographs (for advertisements, packaging, and so on), including stock usage.

Editorial images

The need for release forms for editorial imagery, where photographs can be classified as news or art, is less clear, but many publishers still request them to protect themselves against any future problems. Imagine a restaurant review that includes a picture of dining customers. If, by chance, that picture includes the image of somebody who should, for any number of reasons, not be there, then there could be a legal action brought by that patron against the restaurant, publication, and/or photographer. At a minimum, if the image will only be used editorially, seek verbal permission. However, since most contracts indemnify the publisher against problems arising from permissions, stay safe and get the form signed.

Minimum requirements

A release form should include at a minimum the name and address of the subject and the date the picture was taken, along with some form of words that grants permission for all types of usage of the image. It's also important to note which photographs are covered by a particular release form, typically by including a written description of the photograph. Keep release forms indefinitely. For samples of release agreements, see the Resources chapter on page 186.

It's a good idea to get releases for products and people for commercial use, even if it's difficult for individuals to be recognized.

Metadata

Digital cameras automatically write date and time, ISO, focal length, aperture, shutter speed and on-camera flash fire/no fire to the image file. This data can be helpful when trying to reproduce similar images in the future.

At a minimum, each file should contain the photographer's name, contact information, and up to date copyright statement. Software such as Adobe's Lightroom can automatically apply a standard metadata template to all images on import, which makes tagging your images with the basics a no-brainer.

Tagging images with additional contextual data, such as location taken, image contents, and even related keywords, can help you organize your images for long-term storage, and is often required by stock agencies as part of their searching algorithms. A well-tagged image is far easier to find than one without this information, which at a minimum can help you find that image you know you took five years ago, and even better, may help generate stock image sales.

When outputting images to other file formats, metadata may not be copied to the new file. To preserve this data on all versions of the image, make sure that you check your output settings in whichever software you are using.

Copyrighting your work

All photographs are, by default, considered to be copyrighted by the person who took them, so no action is required by the photographer. However, if your copyright interest is not registered, you may not be entitled to any monetary compensation in the case of a usage violation. In order to ensure all of the rights to your own work, you need to register all images with the copyright office. Luckily this process is relatively straightforward and inexpensive—although not free.

Copyright registration

In the US, copyright registration can be done online. Start by creating a PDF proof sheet of all the photographs that are to be registered. There a fee per submission, but no limit to the number of images that can be submitted at once, so batch up as many as you can. A good practice is to submit all new images for registration once a quarter.

Watermarking

For online use, many photographers place a translucent image across their picture files to prevent image theft, particularly when the pictures are posted on online sites such as Flickr. Unfortunately, watermarking also interferes with the viewing of images.

Digital watermarking solves some of the image-theft problem by embedding license information as imperceptible data in the image. This data can be employed to help find marked images that are being used—with or without permission.

See the Resources on page 186 for more information on services that provide digital watermarking.

Orphaned works

An orphaned work is any copyrighted work that has no associated contact information and the original copyright holder cannot be found. Because images are copyrighted by default, the user of any image has the responsibility to track down the copyright holder before using that image. Orphaned works pose a challenge for the copyright system, since there is no guaranteed way to find the owner. Potential legislation is in the works to consider orphaned works public domain if the image user has carried out all reasonable checks to try to track down the owner. Unfortunately, due to image pirating, works that have been posted anywhere online are easily separated from their original owner information. To prevent your works from being orphaned, you should register them as well as digitally watermark them.

Dealing with infringements

The enforcement of copyright is the responsibility of the copyright holder. As such, if you do find your work printed or posted without permission, your first step is to notify the publisher that the work is copyrighted and that it should be taken down—or agree with the publisher an equitable license agreement. If the images are posted online, you may also notify the online storage provider (OSP) that the image is in violation of copyright laws. The OSP is then legally obligated to remove the infringing images or disable the account.

See the Resources on page 186 for more on copyright and where to submit your registration.

Watermarks help to prevent online image theft.

65

Licensing and pricing

An image license defines the terms of use of an image for a specified period of time (typically by year), distribution (regional, national, or worldwide), type and breadth of use as well as exclusivity.

Type and breadth

A license should clearly state the type and breadth of use. Specifically, the types of usages include, but are not limited to, editorial, packaging, advertising, and marketing. Editorial includes web, print, or video usage in publications such as magazines, books, greeting cards/postcards, ornamental posters, and some websites.

Packaging

If a license is for packaging, usage is granted to print images on product packaging as well as images of the packaged product in editorial, marketing, and advertisement works.

Advertising and marketing

Marketing materials include web or print usage in client publications, such as direct mail pieces, brochures, annual reports, and catalogs. Advertising rights include web, print, and video usage in marketing materials that run in other publications, such as magazines, newspapers, television commercials, billboards, websites, and directories.

Rights buyout

Often, clients have no clear idea of how they will use all the images when an assignment is shot. The images could begin as packaging shots, for example, but then the client may want to use them for print or web advertising as well. As a result, clients often want to buy out up front all the rights to images from a shoot.

A buyout in effect sells the copyright of the images to the client. The client then has the complete right to use those images as desired, exclusively, without limits, indefinitely.

Marketing rights grant usage of a photo for all the client's web and print needs.

Unlimited usage license

Photographers can offer clients unlimited usage licenses. These allow for any use of images by the client without the need for additional payments or permission, but only for a limited period. But "unlimited" does not specify "exclusivity," which should be detailed separately in the license agreement.

Work for hire

Some contracts specify work for hire. In these cases, clients assume the copyright and have complete rights to publish the image, exclusively, without limits, as if they had bought out the rights. However, work for hire contracts typically have much different compensation. Work for hire contracts usually only cover the cost of the production fees (those fees such as the photographer and stylist day rate, studio/gear rental, post production costs, etc.). These jobs are usually editorial, and have the opportunity to open up new avenues of work in the long run, even if the short term pay is less than ideal. Photographers who sign work for hire contracts should negotiate usage for, as an example, the placement of images in a portfolio as part of the contract.

Creative commons license

A creative commons license allows you to grant permission for others to use and distribute your images free of charge, but with certain restrictions—such as allowing or disallowing commercial use or modification of the image. This type of license is rarely appropriate for commercial photographers, but it can be useful for promotional-only images.

Images may be originally shot for one particular purpose, but the client may then buy the rights to use them for other purposes.

67

3. FOOD & PROP STYLING FUNDAMENTALS

Food styling

What does it take to be a food stylist? To begin with, you should be a good cook! Great knife skills, attention to detail, and having no fear of working out creative solutions to problems you've never encountered before are all crucial attributes of successful food stylists, whose job is as much puzzle-solving as it is cooking. Beyond that, there are a few specific tips that can help you with common food-shoot situations.

Faked versus natural styling

Why fake it

When we think about food, most people have a series of idealized images in their head. Syrup on pancakes is slow, thick, and golden; tomato ketchup is a deep and true red; ice is bright, clear, and flawless. In reality, food doesn't usually quite match up to these images. When this is the case, it is the stylist's job to find creative ways of making the photographs measure up to our expectations. And quite often, this means using food styling "magic," such as fake ice, a specific brand of ketchup, or chilled cooking-type corn syrup to represent the less-than-photographically perfect actual products.

Another of the requirements of many commercial food shoots is sustainability—not in the environmental sense, but in the ability for food to survive for hours, or sometimes even days, and still look fresh to the camera. Professional food stylists have made an art out of making food last in a way that would be impossible to do with anything you actually intended to eat, and generally involve large amounts of spray oil (for sheen), Kitchen Bouquet (a browning sauce that can be used for color), paper towels stuffed into places you might not expect, and a certain amount of acrylic.

Making it real

Not every shoot is a large-scale commercial production. And for smaller shoots, or for those where the recipe is the product, using natural styling techniques is the simplest and often the best-looking approach. In these cases, the food styling doesn't differ much from food that's prepared to eat in a restaurant or home kitchen, but special care is taken to use the best ingredients and to keep the food looking as fresh as possible. The recipes may be slightly altered to ensure that every ingredient is appropriately and aesthetically shown in the photo.

Even when the food is real, it's not recommended to eat food off of the set. Food prepared for the camera doesn't necessarily follow safe handling practices, such as avoiding prolonged exposure in the temperature "danger zone" between 41°F (5°C) and 140°F (60°C), not to mention that it has almost certainly been touched and prodded.

Styling tools and materials

To carry out basic styling techniques you should have the following equipment to help prepare and position the food:

- A very sharp, professional knife set
- Brushes
- Tweezers
- Chopsticks/toothpicks/bamboo skewers
- Manicure scissors
- Paper towels
- Lint-free cloths (microfiber types work well, as do cloth diapers)
- Bottle of spray water
- Bottle of spray oil
- A fine sieve
- A small table near the set for last-minute styling needs

For more advanced styling, or styling when working on location, the following equipment is often used:

- Squeeze bottles/eye droppers
- T-pins
- Wedge-shaped sponges
- Handheld clothes steamer with nozzle attachments to direct steam wherever moist heat is needed, such as melting cheese
- Electric charcoal starter (to make grill marks on meats and breads)
- Kitchen or chef's blowtorch (to sear meats or caramelize sugar)
- Acrylic ice
- Portable gas or electric burners

Food-styling tips

What's the best food-styling tip? Be a good cook! In addition, have great knife skills and pay attention to the details. Beyond that, here are some specific tips that can help you with the more usual food shoots you are likely to encounter.

Fresh produce

Always use the freshest produce you can find. It's worth spending a bit more time shopping to find the choicest ingredients. In the best possible world, you would always choose produce that is at peak season, but that is rarely possible. In fact, often a shoot will require fresh produce that is completely out of season. Develop a good relationship with your local grocer or produce company to help you source those hard-to-find ingredients.

Staying fresh

Freshly cut fruit will brown quickly on set. Brush any cut sides with citric acid, such as lemon juice, to keep it looking fresher longer. Citrus fruits dry out once cut. Brush them lightly with lemon juice as needed, or cover the cut portion of the fruit with small pieces of damp paper towels until the final shot.

Most whole fruit will stand on set for hours with no problems. However, under hot lights, any green leaves may dry out and start to turn brown. Turn the lights off when they are not needed, or top the greens with small pieces of damp paper towel to keep them looking fresh.

Blanching vegetables and then plunging them in ice water, rather than cooking longer, helps to preserve their color and firmness.

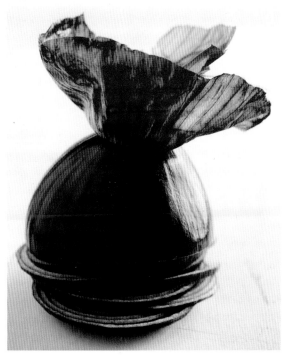

Red onion artfully sliced and stacked

Juicy peaches at their peak

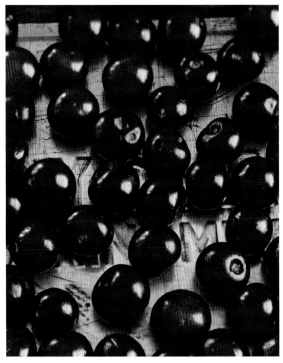

Cherries glint like jewels

Leaves add to the sense of freshness

Cereal

There are two main challenges when styling cereal. The first is ensuring that the cereal looks fresh and crisp, when it can quickly become soggy when milk is added. The second is that real milk looks too thin to the camera. In commercial photography, white glue is often used to solve both problems. In addition to holding the grains or flakes in place without overly moistening them, white glue has a beautiful and opaque gloss that looks the way we think milk should look. Glue also makes it considerably easier to get the perfect spoonful of flakes or to capture the quintessential milk "drip."

The perfect splash

Most splashes you see in commercial cereal images aren't actually milk, but are hand-made acrylic splashes that can be perfectly positioned for the desired effect. You can make your own drips and splashes from wax and glue, but they won't hold up as well. Since shots like this are typically advertising shots of the cereal and not the milk, there are usually no legal or ethical issues with using this trick.

For shoots that do require 100 percent natural product, the stylist and photographer will need to work quickly, and focus more on the cereal (likely garnished with fresh fruit) than the milk. Cream or half-and-half will appear less blue and thin than regular milk.

The perfect portion

Also important when styling cereal is portion size, since a typical shot will show a single serving. Measure the cereal first and find a bowl that doesn't overwhelm the serving size. Stylists may also fill the base of the bowl with shortening so that the cereal has a resting place and doesn't become lost in the bowl.

Depending on the shot and the type of cereal, you may also need to pick carefully through the cereal to remove any broken pieces or, at a minimum, pick out a good selection of perfect pieces to feature on top. A mesh strainer with large-to-medium sized holes can help get rid of smaller crumbs more quickly.

A simple bowl of cereal looks more tempting with a float of fruit.

Dips, spreads, and curries

Styling a bowl full of brown or gray mush is a particular challenge. Dips and spreads require context to add visual interest. Crackers or fresh vegetables elevate the dip by adding color and texture.

Thicker dips, such as bean dip or hummus, or even spreads such as peanut butter, can be dressed up with the addition of ridges created by dragging the back of a spoon in a spiral or back and forth across its surface. Make strokes smooth and continuous, and not too deep. Subtle texture goes a long way.

Curries, stews, and any dish with heavy gravy can be particularly difficult because they are not smooth enough to create aesthetically pleasing swirls, and the gravy obscures the identity of most of the ingredients. For dishes containing larger pieces, use a chopstick to pull a few to the surface to add some shape and interest. If the job allows, cook a few of the ingredients separately from the sauce and add them to the top with only a small amount of gravy dabbed on. A fresh garnish of herbs or spice, or an accompanying side dish, such as rice, can also add visual interest as well as give the viewer a clue to the flavors of the dish. Think about what makes the dish particularly mouthwatering, and emphasize that aspect of it.

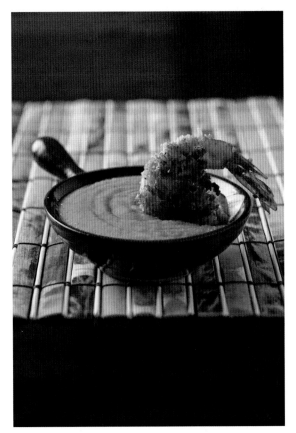

Garnishes of all sorts make plain dips look more interesting.

Pasta

For most pasta shots, ingredients are prepared separately, and hand assembled (rather than tossed together as a recipe might say) for the hero. The pasta will be lightly tossed in oil or a thinned version of the sauce to keep it from drying and to add sheen or color.

Pasta types

Long pastas, such as fettuccine, capellini, and spaghetti, are hand twirled to create attractive loops. Some clients prefer the ends of the pasta not to show.

Individual pieces of short pastas, such as macaroni, penne, and fusilli, are also hand placed at jaunty angles to create visual texture. For most shoots, try to avoid positioning any noodle holes facing toward the camera.

Toppings

Any toppings, such as vegetables—which are usually cooked separately and often simply blanched to preserve their color—or tomato sauce, are strategically placed once the pasta is plated. If the sauce is a bit runny, thicken it by straining it through a paper towel placed over a fine sieve.

Piles of pasta create plenty of visual interest, but be careful that the sauce doesn't look greasy.

Getting in close shows the rustic quality of handmade pasta.

Salad

Like cereal, salads can quickly become soggy after being prepared. It's important to strike the right balance when applying any dressing. Too much, and the salad will look old and wilted; too little and it will look dry and unappetizing. Salads need to look light and fresh.

Keep washed salad greens covered with damp paper towels in the refrigerator until they are needed. Mixed greens are more visually interesting than a single-leaf salad. Chicory and frisée hold up well in a salad, and their frills lighten the overall mixture.

For most leafy salads, it is best to make a false bottom in the bowl you are using (assuming it isn't a glass bowl) with wet paper towels over ice so the salad will not compress once it is on the set. Lettuce leaves can then be carefully placed, covering the false bottom, with the largest leaves going in first. Place the remaining vegetables so that they do not overwhelm the salad, but help to define it. Lightly apply dressing with a brush or drizzle it over with a spoon.

Soup

Brothy soups quickly hide any vegetables or meats they contain unless additional support is provided. For most soup shoots, it's important not to add any additional ingredients to the soup that are not a part of the product or recipe. Using a shallow bowl, for example, or a bowl partially filled with clear marbles can help better communicate a soup's ingredients.

Thicker, smooth soups can look drab unless you add a bit of texture. Use a spoon to create very light swirls in the soup. These need to be subtle, however. Adding texture is good, but too much and the soup can begin to resemble a dip instead.

Any soup will benefit from a fresh garnish that emphasizes the flavor profile of the product. Try a drizzle of olive oil, a sprig of fresh herbs, a dollop of crème fraîche, or a small mound of melted cheese.

Mixed salads have more visual interest.

Subtle swirls and a cheese garnish add interest to this photo of carrot soup.

Meats and poultry

When styling meats and poultry it is best to under- rather than overcook. This will keep the meat looking moist and flavorful, rather than dry and boring.

If the meat is going to be shown sliced, it must be allowed to rest after cooking. This helps to redistribute the juices evenly. Warm meat needs to be shot quickly, so work with a stand-in on the set up until it comes to taking the final shots. If the meat has cooled to room temperature before being sliced it will hold up longer on the set—although it will also look less juicy. Meat should be sliced across the grain.

When shooting whole, roasted poultry, truss the bird to help it brown more evenly and hold its shape. Most whole birds are under cooked and "browned" with painted-on color so that the skin does not shrink, pull, or crack. This ensures a full, plump-looking "roasted" bird.

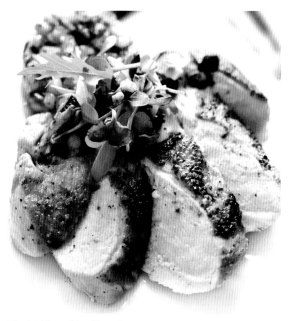

Sliced chicken with grill marks

Raw meat can be beautiful... but you have to work at it.

Rested meat, cooked rare

Fish and shellfish

Grilled or roasted fish and shellfish shots can be prepared normally—in other words, as you would to eat them. As with meats, it is better to undercook rather than overcook. A light brush of butter will help produce browning and you can add grill marks as you would with meats.

Some fish lose liquid after cooking, so when plating up, place a small piece of paper towel under the fish to keep the moisture from oozing out onto the plate. When some fish cook, a protein called albumin can leech out and appear as an unattractive white goo on the cut surfaces of fish. Salmon is a common example of this. Brining the fish, soaking it in a strong salt solution, before cooking can help to reduce the albumin as well as maintain moisture.

When styling prawns or shrimp, have fun playing with the tails! Fan out one of the tails as much as possible, and prop the shrimp, tail up, for a "just eat me" look. Be sure to properly devein shrimp when prepping them. A deeper cut along the back when deveining will give a nice butterflied look.

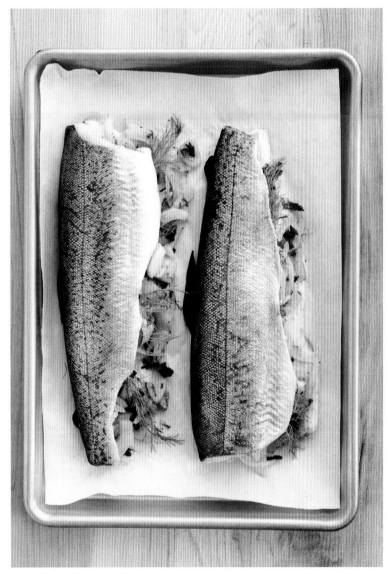

Fish often looks better before it's cooked.

79

Sandwiches

The key to styling most sandwiches is getting the proper height. Sandwiches by nature tend to sag or lean. To overcome this, food stylists will often build a scaffolding with clamps, small pieces of cardboard, and skewers to hold particularly tall sandwiches together.

When styling a sandwich, it is important to understand what it is that you are selling, and make that stand out. If you're selling the sandwich meat, then the meat should appear abundant; if the mustard is the product, then ensure that it oozes out in a pleasing fashion.

To get a great melted cheese look, moist heat is better than dry heat, which can make the cheese look oily. Try using a handheld steamer with a snoot tip that releases the steam as a small, targeted stream. However, the steamer must be used with great care to ensure the bread doesn't get soggy or any lettuce doesn't wilt. A piece of foil, or even a paper towel, can act as a moisture barrier to prevent the steam from going where it shouldn't.

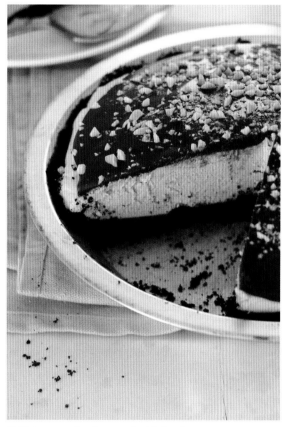

Cold pies are much easier to work with than hot ones.

Cakes and pies

It's always a good idea to start with at least two of the pies or cakes you want to shoot—one that can be used to build a perfect slice and the other to show the perfect slice missing.

Pies and cakes should be at room temperature at a minimum, but they will hold together more easily while cutting if they are chilled.

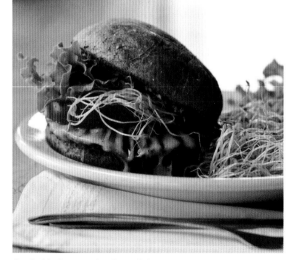

Sandwich photos need to show all the components.

An artful slice

To make a slice, use a sharp knife to mark lightly the edge of the crust a hair's width wider than the size of pie spatula you are using—particularly if it will appear in the shot. Then, carefully cut the slice to that size, gently wedge the pie spatula into place, lift it up and place the slice on the hero plate. Bear in mind that you won't be able to move it easily once you have placed it on the plate. Use this piece of pie or cake primarily as a tester piece to see how the crust holds together. Remember that you have the rest of the pie to take slices from if that one should crack or fall apart.

The perfect filling

Once you have a slice with a good crust, begin to clean up the filling. If the crust is particularly fragile, prop up the back edge using cotton balls or folded paper towels to give it support while you work on the filling. The pie shouldn't be over stuffed, but it is fine to use filling from the remaining pie to build up the slice so that the tip doesn't sag.

Moist fruit pies, such as sour cherry, may need some additional support to hold the fruit within the pastry. In most cases, these types of pies are made with extra thickening ingredients for the benefit of the photographs. This, however, changes the composition of the pie, so they would not be appropriate for recipe photos or product pie images. In these cases, you will not be able to build the slice up particularly high. Instead, use a paper towel to take up excess juice and gently pin the fruit into place where it is needed.

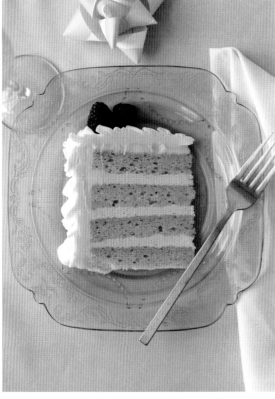

This cake shot takes a nontraditional, top-down approach.

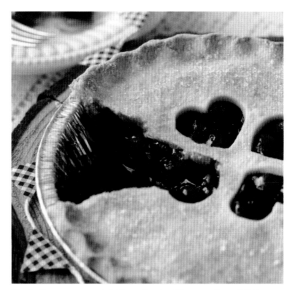

Fruit pies can present a challenge, but for this naturally-styled shot, a little mess was not a problem.

Ice cream

Perhaps more than any other styled food, ice cream's reputation precedes it. While most of the tales of faked ice cream are greatly exaggerated—mashed potatoes are rarely used—the truth of the matter is that a great deal of perfect-looking ice-cream shots are indeed faux. Faked ice cream can hold up on a set for hours, allowing the crew to get the perfect shot without having to rescoop and hope, saving everyone time and money.

A typical faked ice-cream shot is made of a mixture of confectioner's sugar with some sort of fat (shortening, margarine) or canned frosting, with food coloring and any "chunks" mixed in. This ice cream can be scooped and molded into the perfect dome with a collar (that ruffle around the bottom of the scoop), and then textured with a wooden skewer to create a model that is indistinguishable in photographs from the real thing.

Of course, if the product you are shooting is the ice cream or an ice-cream recipe, then real ice cream must be used. Different stylists and photographers have their own way of working with ice cream, but there is one common thread: work quickly and have a lot of the product on hand.

You can scoop ice cream best by running a slightly warmed stainless-steel scoop over the top of a long, flat surface, rather than dipping into a tall, round container. If possible, freeze the ice cream in a flat metal pan (half hotel pan) and scoop from there; the metal will help it freeze solid and the flat surface is easier to scoop from. Finished scoops can then be placed on a parchment or wax paper-lined baking tray or a paper plate, and placed back into the freezer, or in a cooler lined with dry ice, until they are needed on the set. It is always better to scoop more than you think you will need.

These sundaes used real ice-cream scoops that were refrozen once formed. The nonpareils added a challenge—as soon as they touched the ice cream, the colors bled.

These freezer pops, still in their packaging, held up for a surprisingly long time on set, although they still had to be rotated in and out of the freezer.

Drinks

Communicating temperature is the key to a well-styled beverage shot. Cold drinks need to look crisp and thirst-quenching; warm drinks need to look cozy and comforting. Stylists work to convey this with every drink shot even when, as quite often is the case, the drink isn't actually that temperature.

Cold drinks

Ice and condensation are the primary ways to imply that a beverage is cold and fresh. While real ice may be used in editorial shots, such as restaurant features, most studio-produced images of ice in drinks use fake ice—typically made from acrylic, clear plastic or rubber so the drinks can sit on the set for hours, or even days, without melting and changing the appearance of the drink.

Ice types

Acrylic ice varies in price and quality, with the high-end cubes cut, shaped, and polished by hand. These cubes are extremely realistic looking, except there is none of the clouding associated with the genuine article. Acrylic ice cubes sink, and are easier to fill a glass with than traditional ice.

Rubber ice cubes float in a drink, and can be torn to create a realistic crushed-ice effect. They also avoid the "clinking" noise you get from real or acrylic ice, which can be distracting in video shoots.

Ice granules or ice powder are typically used in commercial shoots where crushed ice is needed for drinks or cooler-type shots. These products are toxic though, so be sure to warn everyone on the set not to drink the leftovers.

This Bloody Mary shot was taken in a restaurant, with only a few small tweaks made to the garnish to make sure each ingredient was visible.

When real ice has to be used, it's best to use frozen distilled water. This clouds less and therefore looks cleaner and more refreshing than standard ice-maker ice.

To add condensation to a glass, stylists often use a mixture of light corn syrup and water carefully flicked onto the glass with a stiff toothbrush. Even simpler is to use a small water atomizer; however, the droplets may be too even to look real. To make condensation look realistic, it needs to be applied only where the beverage touches the glass, so mask off the top of the glass to the fill level, as well as the stem, if any.

It's important to keep the glass clean. Glasses with thin walls will look cleaner than thicker glass. Glassware is best handled with lint-free gloves, and cleaned with glass cleaner before it arrives on the set. Use a funnel to fill the glass to prevent unwanted splashing.

Warm drinks

Steam is the first thing that jumps to mind when thinking about warm drinks, but unless the shot is on a dark background, any steam will be invisible. Makes sure the client understands this before going into the shoot.

If the shot does call for steam, the best way to achieve it in hot coffee or tea is to microwave the beverage just before the final shot is taken. Alternatively, steam can be piped in from a steamer tip hidden behind the cup if a hole can be cut in the set. If not, a hot water-soaked cotton ball or tampon (yes, really!) can be tucked in to provide short bursts of steam.

To make drip coffee or tea look freshly poured, small bubbles can be placed on he surface. Although dish detergent is sometimes used, the bubbles it creates have a rainbow color to them, and so are best avoided. A fresh splash of coffee or tea, or disturbing the surface with an eye dropper or pipette is usually enough to introduce a few bubbles. For longer shots, preformed (and reusable) acrylic drops are available from stylist supply shops.

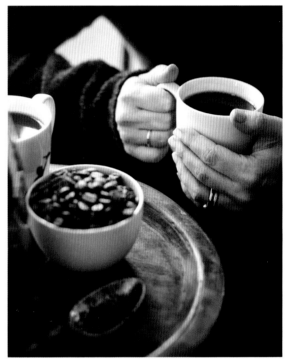

Capturing the cozy feeling is half the battle of warm drink shots.

To achieve a skilled "latte art" look with modern espresso drinks, steam just slightly more non-fat milk than the drink requires in a small pitcher, and tap the pitcher on the counter to flatten out any bubbles. Then swirl the milk around the pitcher before pouring. Slowly pour around the edge of the drink first, and then bring the pitcher up briefly. Finally, bring it close to the surface of the drink, giving it a small wiggle of the wrist, to finish the pour.

Hearts are the easiest of the latte art to create, and look beautiful in shots. Latte art does not last long, however, so be prepared to shoot quickly after the pour.

More information on latte art can be found online, but the key is well-foamed milk and lots of pouring practice.

Latte art on coffee shows how fresh the drink is.

Wine

When photographing wine, it may be a challenge to find just the right glass for the shot. Stemware is particularly challenging for certain camera angles, as the stem may be too tall for the shot. Always have a variety of stemware on hand to ensure you have the right glass for the job.

Red wine often appears almost black in a wine glass. If necessary, thin the wine with water in a separate glass until you achieve the right shade, and then pour the wine into the hero glass.

If wine is needed for a background shot, but is not readily available, a product such as Kitchen Bouquet can be added to water to simulate most shades of wine (or tea). Some brands of ginger ale also make great stand-ins for freshly poured champagne; avoid using soda water as a stand in for champagne as it is too clear.

Red wine can appear almost black; a bit of backlighting (or a bit of water in the wine) can help the red show.

To get a beautiful golden look, cooking oil was used in place of wine in this shot.

Garnishing

Regardless of what you are styling, think about what little something extra you can add to garnish the plate. But forget about the standard sprig of curly leaf parsley; a garnish should always inform the viewer of a flavor of the dish.

Fresh herbs make beautiful garnishes, but they should complement, not overwhelm, the subject. Use small amounts of finely chopped, thin ribbons or small whole leaves of herbs that are a part of the flavor profile of the dish. Herb flowers, such as chive or thyme blossoms, also make a lovely addition to add a bit of color and texture. To keep herbs looking their freshest, I like to store them stem down in a jar of water. Some herbs, such as cilantro, Italian parsley, and thyme, will keep this way stored in the refrigerator for up to a week. Mint and basil can be stored this way for a short time, but will quickly darken around the edges and are best used within a day or two.

If you are garnishing with cut vegetables or fruit slices, keep the proportion in mind; your pieces may need to be cut smaller than you expect. Wait to cut the garnish pieces until you know the shooting angle, and then cut a few test pieces to judge the size.

Coarsely ground spices or nuts, a crumbly cheese, as well as a nice flakey salt, act as beautiful garnishes for many dishes as well, if as before, they are a part of the dish's ingredients or a sensible addition. Always start with a small amount and then add a little at a time as needed.

Garnishing with non-edibles, such as flowers, should be done with care. If the flower is actually edible, this may be a fine choice, but make sure the garnish really adds to the photo rather than crowds it. Avoid garnishing with flowers that are toxic… you don't want to give your viewers the wrong idea.

Garnishes don't necessarily have to stick to the plate. A few raw ingredients placed in the scene can clue the viewer in to what's going on in the food as well as adding visual interest to the shot. For example, a bowl of fresh berries in the background of a berry pie shot makes it clear exactly what is hiding in the pie.

A fresh citrus peel is always a good cocktail garnish. The curls in this lime zest add life to the shot.

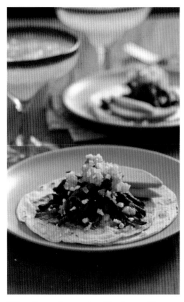

The salsa and avocado add color to this meat taco shot.

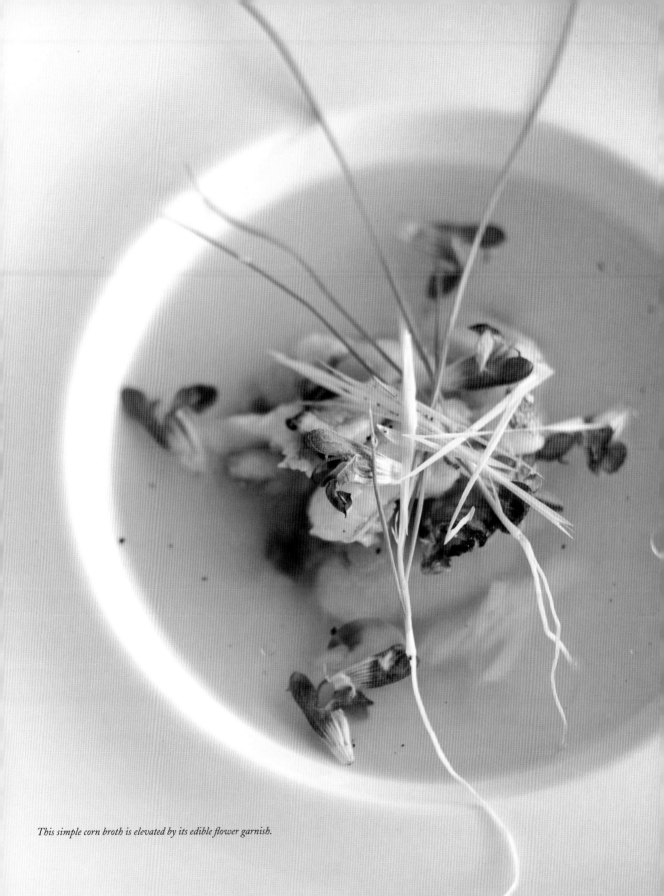

This simple corn broth is elevated by its edible flower garnish.

Prop-styling tips

What food styling is to cooking, prop styling is to setting a table. It involves all the tableware, servingware, utensils, linens, and furniture that tell the story to showcase the food. It's not just about making a beautiful plate; it's about setting the place. It's important to define clearly the story you are trying to tell. Are you at the dinner table, in the kitchen, or at the beach? Did you just roll out of bed, or are you having a late-night dinner for two? Are you at a gourmet game night, sharing rustic farm-to-table comfort fare, or grabbing a satisfyingly messy burger on the go? In order to tell any of these stories, you need the right props.

Choosing props

Start with the big piece—what is in the background of wide shots; what type of table surface gives the right mood—and work your way down to the smaller props. When looking for surfaces to showcase the food, don't limit yourself to tables. An old painted wooden gate laid across a pair of rustic sawhorses makes a convincing picnic table. Scrap pieces of marble make great counter tops. Look for items that have intriguing textures, but that won't distract from the subject.

Thinking in color

Working with a limited color palette is one of the simplest ways to make the food really pop. If everything in the shot is white except the food, there is no question where your eyes will jump—right to the hero. Limited color palettes, however, don't have to be just white. A family of rich browns or cool blues is just as powerful if seen in combination with the right foods.

Bold color can also make for great food shots, but it takes great skill to get all the colors working to support the food, rather than distract from it. Experiment with color palettes

using online tools, such as Adobe's Kuler or myPantone, starting with an accent color within the food. Consider complementary colors: reds with greens, blues with oranges, and yellows with purples. But be careful with any color combinations that are too traditional. A summer scene with Christmas red and green will feel awkward. Use alternative shades that pick up an accent color in the food and that also echo that in the tableware. Crimson cherries with a few bright green leaves still attached will look striking in a green bowl.

Tableware

Food shots require tableware of varying sizes. In general, smaller dishes work better as they allow a reasonable serving of food to make the product look more abundant while keeping the food the main focus of the shot. To fit larger dinner plates or platters into a shot, the angle needs to be quite wide and this makes it further removed from the food.

When using smaller dishes, standard flatware—knives, forks, spoons, and so on—may look out of proportion. With spoons, it's usually fine to use a smaller dessert spoon in place of a dinner spoon. However, salad or dessert forks can't be

Layers of boards may not reflect real life, but they add a special touch.

The splash of color from the linen was a subtle way to add interest.

Calm warm colors and natural woods set the tone in this shot.

substituted for dinner forks as the shape is quite different. Instead, look for forks with thin tines and a simple handle. If the flatware appears too large to the camera, angle the flatware so that only a small portion, such as the edge of the handle, is in the frame.

Similarly, linens need to be scaled appropriately to match the tableware. Cocktail napkins are less bulky than typical dinner napkins and slide beneath bowls and plates without causing them to go askew. Placemats are often large enough to appear as full tablecloths, but at a fraction of the price. Table runners can provide a nice touch of color. Bulk yards of cloth and rough-cut quilting quarters provide even more options for adding texture and color on a budget.

Beyond these basics, look for interesting accessories to add unique accents and to set the tone of the shot. Ribbon or twine, a bouquet of freshly cut herbs or flowers, unusual glassware, and wooden serving boards all add a modern rustic look. Parchment or butcher paper can be used to imply bakery goods and give beautiful separation, so that the elements of the photo appear distinct instead of running into each other.

The round bowl contrasts with the square biscuits.

Setting the table

Once you have your prop options ready, the next step is to put them together on the set. Keep in mind the camera angle as you set the props. Ideally, the camera will already be in approximately the right position as the table is set, so you can simply look through the viewfinder to see the effect each element is having on the whole. However, if the camera is not available, stand at its approximate height and position after you place each prop, and look for any areas of overlap and tension.

Think in layers, and alternate colors and textures to build visual interest. Set a soup bowl on top of a napkin nestled in a shallow saucer. Try a stack of salad plates paired with a pile of salad forks. Use lightly curled parchment to separate a scone from its plate, perhaps with a lightly folded napkin tucked to one side.

Work with lines and circles to pull the eye into the hero. Flatware should always be positioned to draw the eye in, rather than send it out of the frame. But don't make the mistake of over-propping, or the hero will become lost in the clutter. Continue to try new combinations of props, but don't be afraid to remove ones you have already placed in order to leave the hero some breathing room.

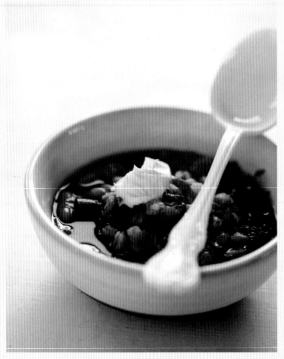

White props keep the focus on the food.

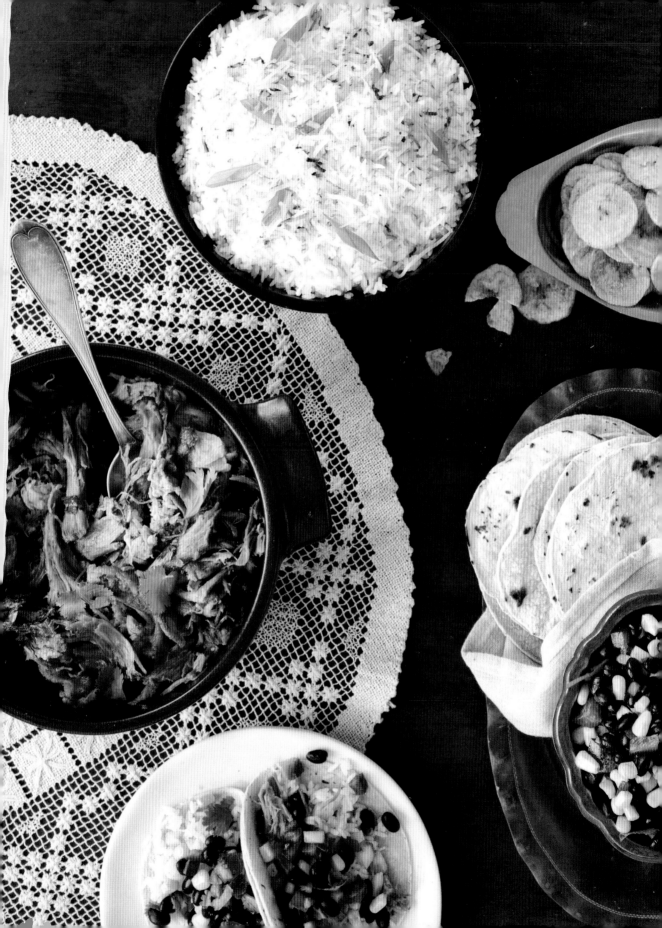

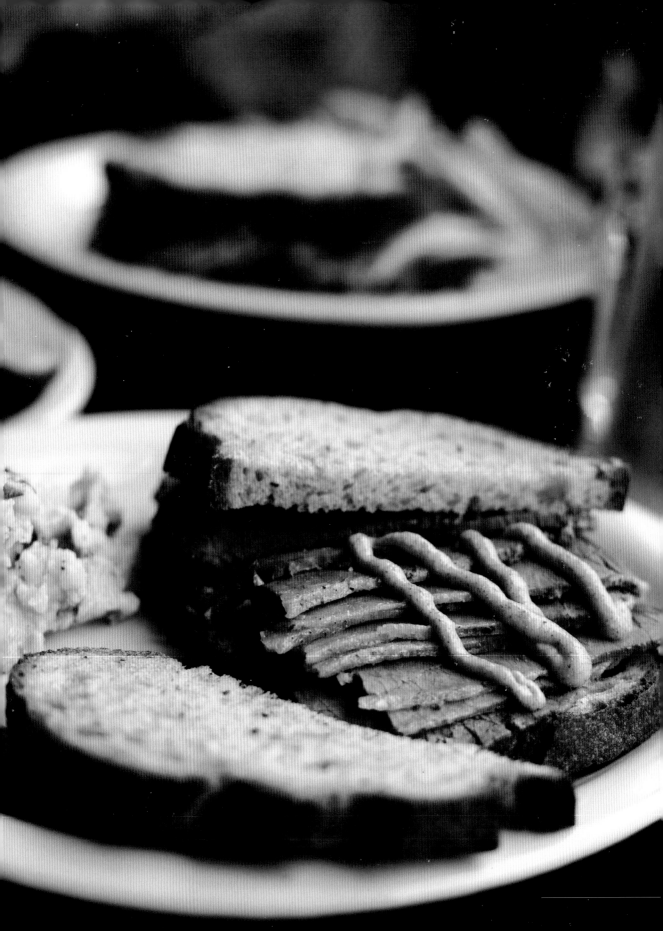

Styling on location

Styling on location means dealing with many unknowns, so it is important to be prepared for any eventuality—from no tables to work on, no cooktops, ovens, or refrigerators, or even at times no power. Asking the right questions before the shoot about the facilities that will be available is crucial to a successful session; visiting the location prior to the shoot is even better. Make sure you understand where you will be preparing the food and where the set will be. If the actual photography is to take place in the location kitchen, then you won't be able to style the food there.

Styling without a kitchen

When no kitchen is available on larger productions, portable kitchen trucks can be brought in to prep the food. On smaller jobs, stylists may have to make do with portable burners, coolers with dry ice, and boards on saw horses acting as makeshift tables set up in a side room, garage, driveway, or back alley. Make sure to ask for, or bring along, extension cords, buckets or plastic tubs, and chairs or stools, but always find out in advance where the nearest source of water is located.

If you are working outside on a hot day, try to set up the prep area in a shaded spot, or ask for a tent. Cold days can be equally challenging; request or bring a portable heater if necessary.

When working outside, keep an eye out for small bugs (or other things that may end up blowing onto the food). There isn't much you can do about the flying ones, and you may have to on occasion pluck them off the hero.

Working with chefs

Plating food for presentation in a restaurant is very different to styling food for the camera. Most restaurants tend toward large tableware—this may look beautiful when presented at the table, but it can dwarf food in photographs. It is the job of the stylist—or the photographer if no stylist is involved with the shoot—to work with the kitchen staff to achieve the best-looking food for the camera.

Consultation

Some food photographs better than others, so a review of each dish to be shot with the chef will help get the right set of images for the restaurant. Often, chefs will have snapshots of the dishes for use in the kitchen. Ask to see these before the shoot begins and talk through any issues arising from each dish, as well as any recommended side dishes or beverage pairings. If a particular dish looks problematic, suggesting an alternative before the shoot gets underway is the best time to get things sorted. Most chefs will appreciate this insight.

As you discuss each dish, suggest smaller-than-normal tableware and simple, white, round plates. Meats should be prepared on the rare side so they remain juicy, and resting the meat is critical—more so than the meat being warm for photographic purposes, so it doesn't leak juices onto the plate. Encourage the chef not to overgarnish and to apply any sauces sparingly. Extra sauce can always be brought to the table if it is needed. The dishes should, of course, not vary too much from the normal kitchen preparation, or patrons may be confused, disappointed, or misled by the images. But small refinements that maintain the spirit of the dish can be made to help the dish translate from three dimensions to two and to allow the food to hold up to 10 or 15 minutes on the set.

Timing

It is also important to manage the rate at which the dishes come from the kitchen, so food is not prepared before it can be shot or the photographic team isn't sitting around waiting for the next dish to arrive. The best-case scenario is to shoot two separate platings of each dish. The first is to fine-tune the set and the lighting, so the second can be shot quickly while the food is still at its freshest. Those extra plates can also work nicely as backgrounds in pulled-back, environmental shots, even after they are past their prime as the hero.

For shots involving chefs preparing food, engage them in casual conversation and encourage them to ignore the camera and cook as they would normally to avoid shots looking too posed. Giving them an active task, such as chopping or pan frying, will help to keep them relaxed and add interest to the photographs. A slightly long lens will keep you from appearing in their working space.

4. PROFILES & CASE STUDIES

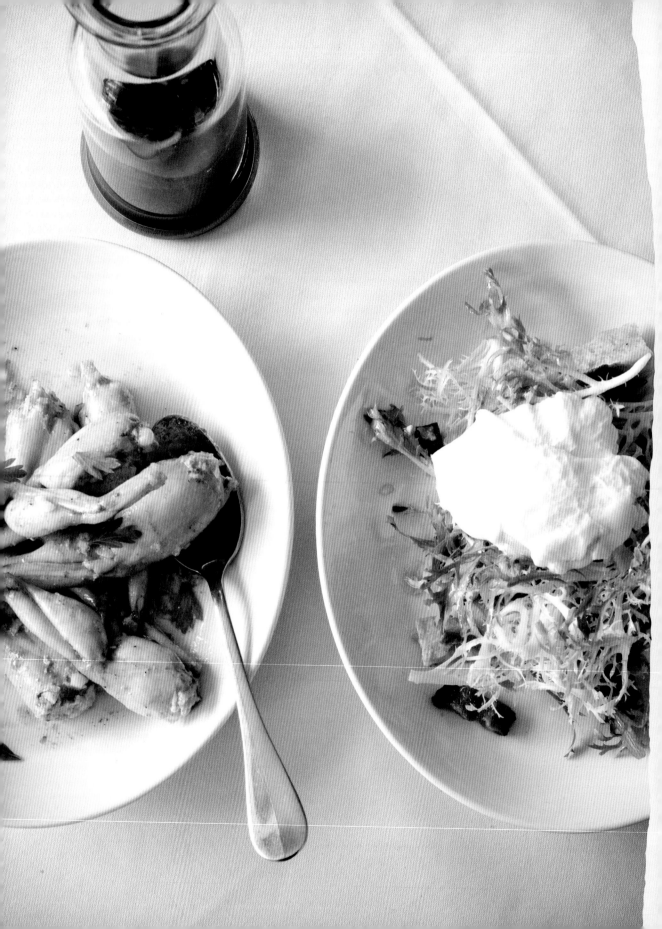

Photographer profile: Iain Bagwell

Iain Bagwell's start in photography came in 1992, when he moved away from his degree in graphic design and took an assisting job with a local commercial photographer. After four years assisting, working almost exclusively with food and related topics, he opened his own studio. Iain worked on advertising and packaging for more than 1,000 products, 50 cookbooks, and more than 100 magazine covers for publications in the USA, Europe, and Australia. Don't be surprised if you pick up any current food magazine and find his images looking back at you.

Diversity

Iain's broad experience has given him a unique perspective on the future of the food photography industry. He emphasizes that having a diverse portfolio is crucial for any photographer, rather than relying too heavily on any one area. Stock photography continues to be a large part of the industry, and there is the potential for new opportunities in HD video as well, despite the greater demands it makes on the stylists and photographers. Photographers must be flexible in order to meet the needs and budgets of clients, but Iain says, "the photographers who strive to be different and define their own styles will always find work."

Contrasts

For Iain, major clients, such as fast-food clients, mean assembling big teams that can quickly amount to a very large number of people on the set. Everyone involved with the images, from art buyers, art directors, creative directors, account executives, and brand managers to stylists, assistants, reps, and studio managers, has some role to play. Working with so many people means there is less flexibility and creativity on the shoot itself. In contrast, however, just as many of his shoots require Iain to take on multiple roles. "I recently shot an entire cookbook of a hundred images and did all the prop styling myself as there simply wasn't enough budget to hire a stylist. I will often move things on the plate that has already been styled as things don't always look as good in camera as they do when they are being plated. I often do my own props if the shoot consists of things that I have in the studio. Often when on location—especially in homes and restaurants—I will improvise."

Individual approach

When shooting in restaurants, Iain starts with getting to know the place. "Every restaurant has different ambience, lighting, food, personalities, service items, and space. To really bring restaurant food alive I like to spend 30 minutes or so just getting to know the chef."

More of Iain's work can be found online at iainbagwell.com.

Case study: A restaurant review

PHOTOGRAPHER: Iain Bagwell

STYLIST: Food styled by the chef

CLIENT: *Southern Living Magazine*

USE: Editorial

LIGHTING: Available light

CAMERA: Canon EOS 1Ds Mark II

LENS: 16–35mm f/2.8

Camera on a tripod, shooting top-down on the subject

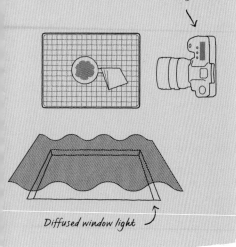

Diffused window light

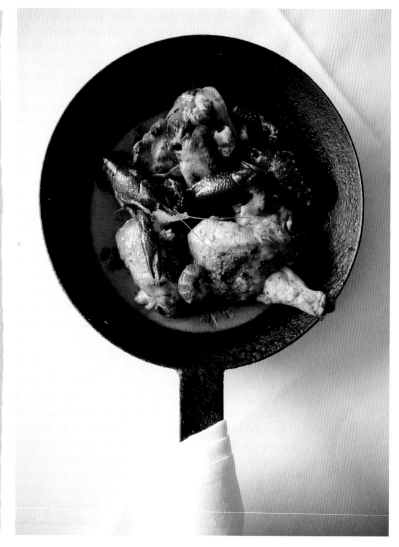

Shot at Ecco, in Atlanta, GA, USA, for *Southern Living Magazine*, these photographs illustrate a story about restaurants with unique Sunday menu events, bringing together both tempting close-ups of the classic family-style Lyonnais menu woven together with anticipatory shots of the servers preparing for the event. The shots work together to evoke the sense of the attention to detail the restaurant is known for.

Each of these images had to be shot several hours prior to the actual event seating, to avoid intruding on customers' dining experience. To bring the feel of the event to life, Iain shot in the event room, to capture the same lighting characteristics.

For the food shots—langoustine and chicken; frogs' legs and salad (see page 98)—a table was pushed close to a diffused window to the side and slightly behind. The tripod was placed on the table to shoot top-down on both dishes. The simple crease in the tablecloth brings a formal, restaurant feel to both shots and adds an interesting compositional element.

All styling and propping for this shoot was done by the kitchen with guidance from Iain, rather than a stylist, with an emphasis on showing the food as accurately as possible. Although Iain typically works with prop and food stylists when in the studio, this is typical for Iain when he shoots in restaurants. He notes, "I like to let the chefs present their recipes in their style. I don't think it is a good idea to reinterpret their ideas as they may find themselves having customers take issue." He does, however, suggest smaller plates that flatter the food, which most chefs are happy to accommodate. Here, by keeping the table sparsely propped, the homey French food becomes the star of the shot.

Iain found a quiet moment with a server naturally backlit to highlight his uniform. "I love the light coming through the window as well as the apron. His pose seems slightly aloof and uninterested and, not wanting to stereotype, I think he seems slightly Gallic."

Lit with just available lighting—some natural, some overhead—the final shot captures a behind-the-scenes feel of the preparation for a big event in a very photojournalistic style. "There is a kind of camaraderie as well as an urgency to the shot. At the actual event the server in the foreground was the main server, so I think it shows a certain dedication by him."

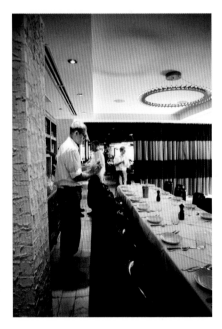

Photographer profile: David Clancy

Long-time photographer David Clancy began concentrating on food photography in 2008 while working for the Food Network as a production assistant. When cooking programs moved their production to the west coast, the need for food photographers with on-set experience grew, giving David the opportunity to take the "beauty" shot stills needed while the videos were being made.

Expertise

David says: "Food photography on a television set has to be done quickly because there are so many different dishes to photograph in between takes. To keep up the pace, we use the same basic setup for every dish or drink, with just minor tweaks and adjustments for each one." It is up to the skill and expertise of the photographer to bring something fresh and interesting to the shot, despite the limited time available and the standard set and lighting.

Lighting styles

Depending on the needs of the shoot, David works with both natural and studio lighting to achieve his images. Typically, when shooting on a television set, studio lights are more usual, but the goal is always to use whatever lighting scheme makes the food look best and one that suits the overall approach of the chef. One of David's favorite pieces of equipment is a snoot for the studio lighting head. This puts a "laser-like focused hard light on any subject, producing a great highlight."

One of his top clients is Guy's Big Bite, which features Food Network star Guy Fieri in the studio demonstrating his favorite home cooking. Still images for these recipes feature crisp lighting with colorful backgrounds to make as strong a statement as Guy's flashy rocker style.

More of David's work can be found online at www. photo.net/photos/photomano.

Case study: Promotion for a television show

PHOTOGRAPHER: David Clancy

STYLISTS: Morgan Hass and Joe Lazo

CLIENT: Food Network — "Guy's Big Bite"

USE: Promotional material

LIGHTING: Strobe

CAMERA: Canon 5D Mark II

LENS: Canon 24–70mm

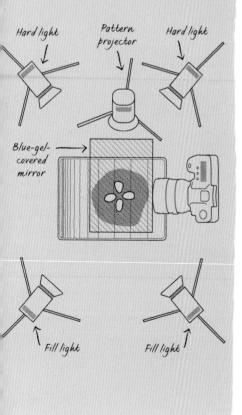

For this dish, stylists Morgan Hass and Joe Lazo placed the oysters on a bed of rock salt in a circular pattern to show as many of the ingredients as possible, and to make the oysters pop. The cheese was added and torched just before the final shot was taken to make it look warm and bubbly.

The oyster plate is set on a piece of milk glass, curved to create an infinite horizon. The lighting for the shot is primarily driven by the needs of the video, which require a large number of lights to shape the food and provide motion to the background. A Dedolight pattern projector aimed at a blue-gel-covered mirror bounces the light onto the underside of the milk glass, creating the glowing blue background that cycles through different patterns. Dimmed hot lights with Chimera diffusers sit to the right and left of the dish to act as fill lights, while additional Dedolights, placed behind and above, surround the setup to shape the hard light on the subject.

Case study: Promotion for a television show

PHOTOGRAPHER: David Clancy

STYLISTS: Morgan Hass and Joe Lazo

CLIENT: Food Network — "Guy's Big Bite"

USE: : Promotional material

LIGHTING: Strobe

CAMERA: Canon 5D Mark II

LENS: Canon 24–70mm

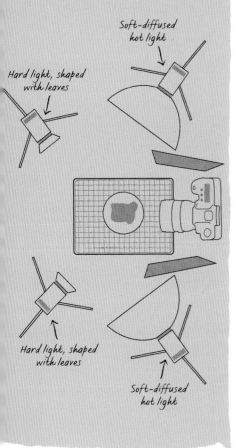

Soft-diffused hot light

Hard light, shaped with leaves

Hard light, shaped with leaves

Soft-diffused hot light

In this shot, white fish is cooked inside the paper casing with a slice of lime and a selection of vegetables. There is a lot going on inside the casing, and as a result it is easy to lose focus on the fish. The composition and angle of the shot need to complement the paper casing in order to show as much information about the dish as possible.

Morgan Hass and Joe Lazo styled this dish by peeling back the paper to reveal the fish and other contents and placed the vegetables in such a way that the viewer could see every ingredient. A little sauce produced during the cooking process was added to make the fish look even juicier for the shot.

The lighting setup was similar to that used for the oyster image (see opposite page). The two soft-diffused hot lights on the left and right were dimmed and flagged off precisely to suit the shape and build of the dish. The hard lights at the back and on the sides were shaped with leaves inside the light itself, giving the vegetables and fish a little glow from the back without overexposing the white flesh of the fish. This gave the overall composition more depth and made it more appealing to the viewer.

Case study: Promotion for a television show

PHOTOGRAPHER: David Clancy

STYLIST: Morgan Hass

CLIENT: Food Network — "Guy's Big Bite"

USE: Promotional material

LIGHTING: Strobe

CAMERA: Canon 5D Mark II

LENS: Canon 100mm

This is a drink called the Roasted Tomato Bloody Mary. It has many ingredients, but the two main ones are pickled green beans and, not surprisingly, roasted tomatoes. The image needed to depict accurately the color of the drink as well as the pickled green beans used in the drink and their color in their finished state in the Mason jar.

Only hard lights lit this particular photograph. Each Dedolight was strategically placed and dimmed to create the exact look required for the shot. The advantage of using hard lights was to pinpoint where the lights would land and the effect each would have on the subject. The lights also left shimmers of light bouncing off the rim and body of the glass and ice.

David explained: "I needed to concentrate on my exposure, which was five seconds at f/22, and to take special care to avoid overexposing the pickled beans in the background and underexposing any part of the drink in the foreground. I also wanted to be sure that the viewer could see the condensation on the glass and a shine of light bouncing off the Mason jar for that all-important highlight."

To style the drink, Morgan Hass chilled each glass just enough to produce condensation. The pickled beans were positioned precisely so that the camera could capture each individual one.

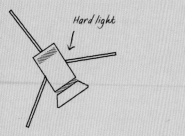

Hard light

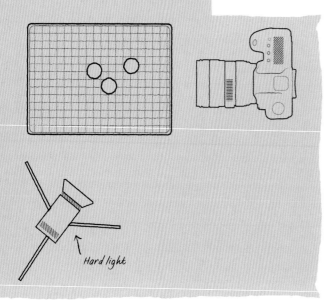

Hard light

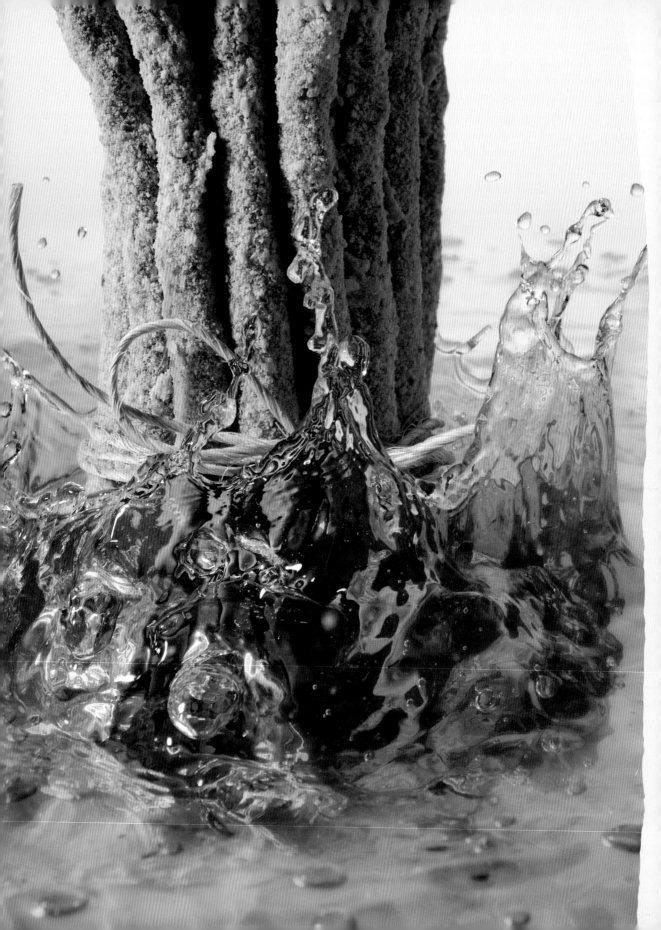

Photographer profile: Colin Cooke

Colin Cooke started his photography studio in New York in 1981. At that time, "food tricks were the norm. We used to pour Brylcreem Hair Tonic in the cereal bowls, raise the vegetables in the soups up with marbles and blocks, make fake ice cream, you name it. Food styling, like the lighting, used to be very stiff. Corporations had strict guidelines, for example, The Cool Whip dollop was "The Cool Whip Dollop." A small army of food stylists was trained to make one style and one style alone. We made money. We worked long hours. I remember being triple booked day after day. One day I gave an assistant a letter to post on the street corner. She said 'Would you like to take it and get some fresh air? You've shot 12 days straight and not been outside once.' Work was that plentiful. Crazy."

Early days

Colin began his career as a still-life photographer and quickly moved into a food specialization. "New York is/was all about specialization. The shooters outside metropolitan areas did not have that pleasure. They had to shoot everything. In New York there was too much confusion if someone brought in a book with fashion and food. So are you a food or a fashion photographer? So most of us concentrated on one topic or another and stayed there."

Trained on studio lights, Colin amassed a huge collection of lighting gear: "24 flash heads, eight packs, stands of every description, a dozen tungsten lights, and three huge Northlight rolling stands." Today, after a push from stylist Paul Lowe, Cooke has moved to shooting typically with natural light. "Natural light is and has been recognized by food clients as the preferred light source. Major clients tell me they want their sandwiches, steaks, desserts, cocktails, or whatever shot in natural light. Thank you Martha Stewart and Donna Hay!"

Digital innovations

Now, Colin says, the world of food photography has changed. "Digital still marvels me. But it is an amazing technology that has taken all of the magic out of our business. Sounds funny but we still-life shooters not long ago used black cloths to throw over the back of our large-format cameras, look upside down to see what others could not. If you invited an art director to look upside down under a dark cloth they usually replied 'Can I see a Polaroid?' Now technology has made 'prosumer' cameras that allow art directors to take their own photographs if they prefer. Recently a food client beamed to me that he was able to shoot cupcakes and use them on the company website instead of having to hire someone. Options abound now."

An evolving industry

"Food changes all of the time. The combinations are endless. And so is the packaging. Food in the 1980s became interesting. People started eating sushi! Fresh vegetables could be found! Balducci's and Jefferson Market here became temples where the food stylists could shop in the early morning. Chefs were becoming stars. The Food Channel started. People were interested in eating better and seeing pictures of delicious food helped them get over their shyness of trying something new.

"I recently met someone who works at a digital agency. They have a thousand people working there. Their net income was up 40 percent last year. He explained that digital agencies, like his, were taking the work from traditional ones. No paper and no TV is their motto. They have major clients. They are working feverishly with social networking to get the same information that used to come to us via TV, newspapers, magazines, and radio. I realized that my freelance business falls into the traditional category. I told him that I ask myself where will this all lead to in, say, five years? He said, 'Colin, your question should be one year.'"

More of Colin's work can be found online at www.cookestudio.com.

Case study: Corporate advertising

PHOTOGRAPHER: Colin Cooke

STYLIST: Nir Adar

CLIENT: NitroNY for Dove/
Mars Chocolate

USE: National advertising campaign

LIGHTING: Diffused flash

CAMERA: Canon 1Ds Mark II

LENS: 100mm macro

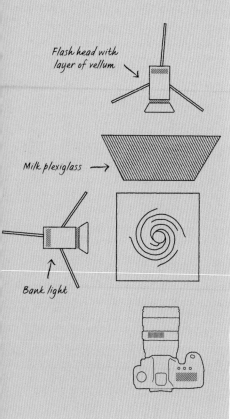

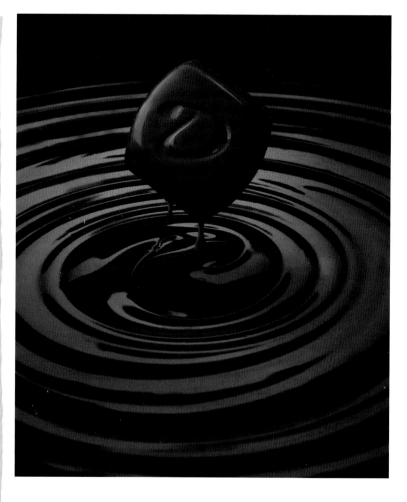

The key to this layered shot, which took two full shoot days to create, was to get just the right materials and light to create a lusciously smooth feeling of chocolate.

Day 1

Colin first tackled the swirled chocolate "pool" by building a 30 x 30-in (76 x 76 cm) clear plexiglass box with 4-in (10 cm) sides to hold a mixture of commercially prepared vanilla pudding mixed with chocolate-colored latex paint. Colin placed a vertical piece of milk plexiglass just behind the "chocolate box" with a single flash head with a layer of vellum over the 8-in (20 cm) reflector.

The food stylist poured the mixture in and swirled it to setup and allow the lighting to be set. The light was then moved around until just the right highlights were achieved. "It was important that it was not too 'hot,' or bright. We needed to see the chocolate color even on the highlights. Too bright a highlight would lose the 'luscious' feeling." By using just one backlight Colin was able to get a single directional highlight, and keep the rich, chocolate look.

"A big spoon was used to swirl the mixture on set. We did it over and over again. I probably did about 40 variations of the swirl. The most important aspect for the food stylist was getting the mixture plump enough to give us soft, rounded ridges. Getting this background shot took one preproduction day for the stylist and one shoot day. I set the lighting up on the food stylist preproduction day. We finished the chocolate swirl toward the end of the first shoot day."

Day 2

"On the second shoot day we poured the chocolate mixture back in. It was for me very important that I shoot the candy in the same set and pick up the ambient qualities of the pool. I rigged the chocolate candy from the back with armature wire and hot glue. The candy piece with the D logo was made by a model maker. It was made out of a resin mixture. I positioned it right where we wanted it in the ad. I turned the background light off and put a 12 x 12-in (30 x 30 cm) bank light on the left-hand side. For a bit more highlight I positioned a mirror overhead and a thin white card on the right for just a touch of fill-in reflected light.

"The candy looked great, but seemed to be floating in air. It needed some drips to anchor it to the shot. The model was a bit too perfect. I shot first with one drip off the bottom, but that was too symmetrical with the candy, and so I added a smaller shorter one just to the left. We also made the candy look more in situ by pouring a thin liquid chocolate mixture over the top. That filled in the D letter a little and softened the lines."

To complete the shot, the studio manager layered the separate shots of the swirl, candy, and drips and merged them together to create a convincing single image. This included reversing the drip direction and shadowing the drips as a reflection in the swirl. "These are small details, but so important."

Case study: Product marketing and packaging

PHOTOGRAPHER: Colin Cooke

STYLIST: Paul Lowe

CLIENT: FoodArtsNY

USE: Marketing materials and packaging

LIGHTING: Available light

CAMERA: Canon 1Ds Mark II

LENS: 100mm macro

A rich, chocolate-colored plate and fabric help capture the mouthwatering qualities of this molten chocolate cake image. The lighting is simple, with daylight (on an overcast day) to the right and a white wall to the left acting as a reflector to bounce a little light back, just barely opening up the shadowy side of the subject. A very shallow depth of field helps to focus the viewer's attention to the important part—the oozing chocolate.

The challenging part of this shoot was achieving just the right styling on the drip. Stylist Paul Lowe microwaved the cake for a short time, but it didn't provide the right look to communicate "molten chocolate."

Colin notes: "Our business is all about problem solving. The cake had some fondant (white) that had mixed with the chocolate inside. [Paul Lowe] had some chocolate syrup and added it after he had opened the cake off set and cleaned out the inside. To reintroduce the fondant he slowly poured cream on top of the syrup. A little sprinkling of powdered sugar and a garnish and we had it."

Daylight from the window opposite a white wall

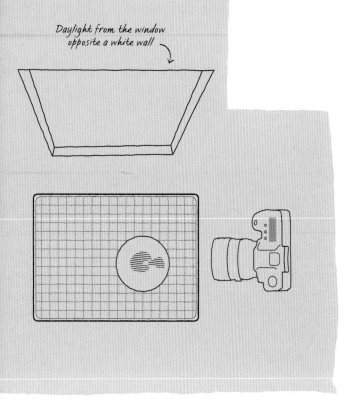

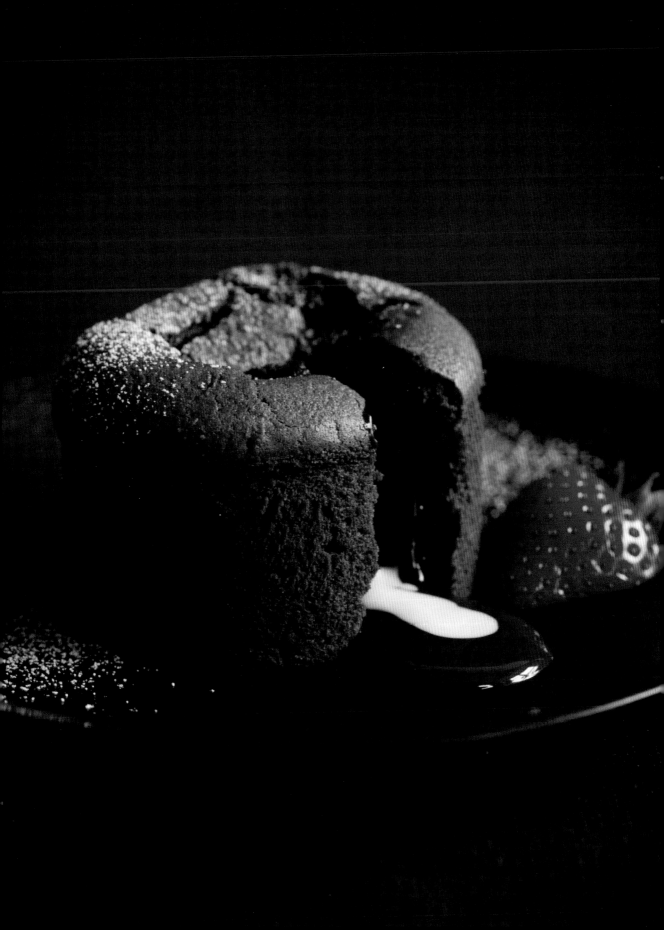

Case study: Editorial

PHOTOGRAPHER: Colin Cooke

STYLIST: Paul Lowe

CLIENT: *Interiors Magasonet* magazine

USE: Editorial/magazine

LIGHTING: Natural light

CAMERA: Canon 1Ds Mark II

LENS: 100mm macro

This image was part of a large series of photographs Colin created on the subject of chocolate for the stylish Norwegian magazine *Interiors Magasonet*. Paul Lowe was both the food and prop stylist for this shoot.

All the shots were taken in natural light using dark, rich backgrounds. Colin says that often "in ad work I'm shooting on white for silhouette. The texture of these surroundings made the chocolate look even richer."

Four large windows were to the right of the subject, and a fill card was used to the left. The fill was set far enough away to maintain full, dense shadows, and this added to the luxuriousness of the final image.

The simple and elegant lighting setup is paired with the simple and beautiful food styling. Chocolate syrup fills the bottom of the glass; there is milk on top and a good sprinkling of coarse cocoa powder almost spills over the rim. In front rests a thin breadstick (grissini) dipped in chocolate sauce.

The image was shot at f/2.8, which produced a depth of field just deep enough to allow the leading edge of the chocolate on top to remain in focus.

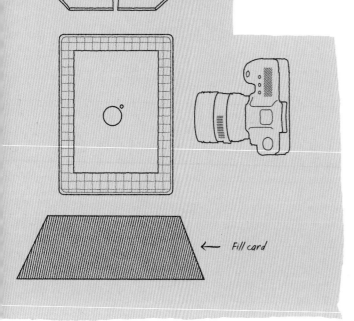

Daylight from four windows

← Fill card

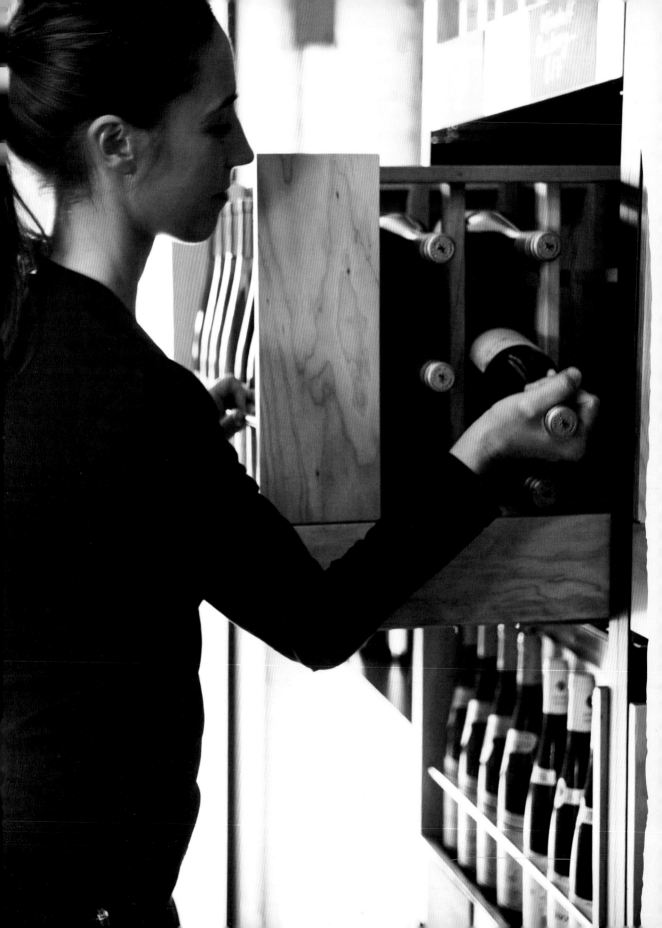

Photographer profile: Lara Ferroni

"It was a batch of raspberry scones," says Lara Ferroni, "that first led me into food photography." After her exit from the high-tech world of Microsoft, she found herself with time to develop her old passion of cooking. "I never had time to cook when I was in software development, but suddenly I had a year to travel and explore what I wanted to do next, and I fell in love with cooking again." More specifically, Lara fell in love with styling and photographing food. A quick snapshot of those scones led to a near obsession with taking food photos. For a year, she simply played with food, waking up each morning with an idea of something she wanted to make, shoot, and then blog about. She started garnering a bit of attention from publishers and food producers and soon found she had stumbled into a new career.

A natural approach

At the time (in 2005) there was little information about food photography and styling available, so she started amassing her knowledge and sharing it with others who were going through some of the same struggles via the internet. "Food blogging was just becoming something people were talking about, and I could see that bloggers were struggling with their food photos, as I was… I just had more time to commit to learning than most people. So I started a new blog, Still Life With, dedicated to food styling and photography using a more natural approach: natural light and real food, following the recipes that you could eat. Everything else I could find about food photography at the time was about strobe lighting and fake ice cream, but I knew there was more going on than that."

Since Still Life With's inception, more and more photographers and stylists have become open about their processes and techniques. "There is a real spirit of giving back that I see now in the industry, and I think that has made the work even better. It is such a joy to do what we do, and I feel exceptionally lucky to have landed here."

Lara now focuses her work mostly on editorial photography, especially shooting recipes and cookbooks that she typically styles and shoots herself. She has over 10 cookbooks to her name, including one she also penned: *Doughnuts*.

More of her work can be found on her blog: laraferroni.com.

Case study: Packaging photography

PHOTOGRAPHER: Lara Ferroni

STYLIST: Lara Ferroni

CLIENT: Farm to Market Foods

USE: Packaging and other marketing materials

LIGHTING: Natural light

CAMERA: Canon 5D Mark II

LENS: 100mm macro

This shot was for the packaging of a new bagged potato product. The client wanted to convey the fresh nature of the potatoes and came prepared with sample shots from the design firm, complete with sample layouts so the space for text placement could be planned.

"To style the shot, we used the actual product and microwaved it as directed, but undercooked it slightly to preserve the rich redness of the potato peels," explains Lara. "The potatoes were carefully hand placed on a plain white plate to get the right balance of peel to flesh showing, in an attractive, natural looking pile. I hand applied a portion of the seasoning mixture to ensure it was adequately shown. Since cooked herbs quickly lose their identity, a garnish of the major flavoring (oregano, lemon, or garlic/rosemary) was tucked to the side to make it easily identifiable at a glance and to differentiate the flavors of the product."

Lighting was kept simple, with diffused natural light coming from a large bank of windows behind and slightly to the right. A large white fill card was placed to the left of the potatoes, with a small mirror to the front right for additional highlight on the main focal point.

After the shots were completed, the design changed slightly and the images were flipped to accommodate the new text layout.

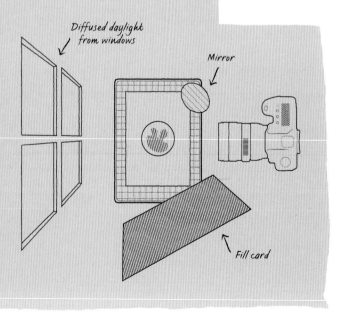

Diffused daylight from windows

Mirror

Fill card

Photographer profile: Lara Hata

Lara Hata launched her foray into photography while still in high school, but started specializing in food photography in 2003 after becoming close friends with a group of talented stylists she had met while assisting. Her work is mostly editorial, with a strong focus on cookbooks and magazines.

Many of her cookbooks are single-subject productions (*Panini, Coffee, Tequila*), always with an interesting creative challenge to make each shot unique. For David Lebovitz's ice-cream cookbook *The Perfect Scoop*, Lara also had the added challenge of shooting real ice cream. "We just made sure that the lighting and composition were perfect before putting the ice cream down. We did maybe 12 captures and that was it." Lara recalled. "A little melting is OK, but we didn't want a puddle."

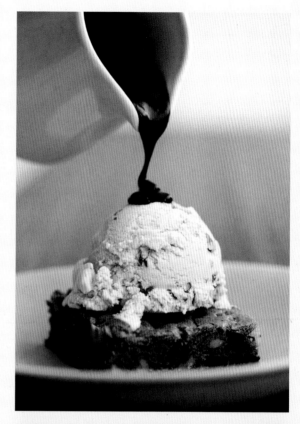

Lighting

All the shots in *The Perfect Scoop* were done in 100 percent daylight. "Food always looks best in natural light. So that was a given," says Lara. Shutter speeds were often 1/30 second or below, so a tripod was used to the right, next to the key light—a sliding glass door. A fill card to the left opened up the shadows, but the light was also reflected back from the white walls of the house and ceiling to create a very soft and even lighting effect.

Props

All the prop and food styling was done by veteran George Dolese, who has styled for more than 50 cookbooks. Together, he and Lara chose a casual direction, "not over-propped and precious." While you might expect some fancy food-styling tricks, such as deep freezing the ice cream, George simply made the recipe as directed, scooped, and served.

For more of Lara's work, see her online portfolio at larahata.com.

Case study: Cookbook Photography

PHOTOGRAPHER: Lara Hata

STYLIST: George Dolese

CLIENT: Ten Speed Press

USE: Cookbook/Editorial

LIGHTING: Available light

CAMERA: Contax 645

LENS: 80mm

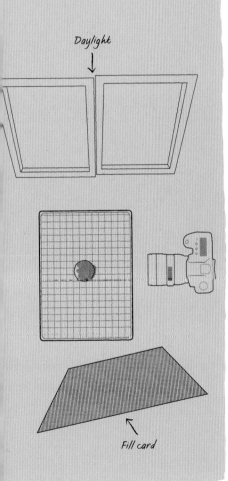

To make the ice cream for *The Perfect Scoop* look extra appealing, Lara shot close, from a low angle with lots of bright, warm natural light. She aimed to make "you just want to reach in and grab the cone off the page. We also were not worried about the ice cream melting a little. That only added to the appeal—seeing the ice cream melting on a hot day. We actually kept shooting after it dripped onto the surface, but those shots weren't the final ones that made it into the book."

Lara often shoots a variety of shots of a single dish, starting from pristine and moving into messy, as she does in these shots of chocolate ice cream. A simple French linen kitchen towel gives the shot some color and softness, but doesn't take away from the focus on the velvety ice-cream scoops. Since the ice cream is real, only a few shots can be taken before the messiness begins, and the spoons are artfully employed.

Lara and George brought the book's Brownie Sundae shot to life by adding a bit of action (see photo on the facing page). Chocolate sauce was caught mid-pour on the freshly scooped butterscotch pecan ice cream that was perched on a blondie (a non-chocolate brownie). The teal plate and dark tropical wood surface add touches of color and visual interest, while the soft focus on the pouring sauce directs the readers' attention.

Photographer profile: David Land

New York-based lifestyle photographer David Land may not consider himself a food photographer, but his work with travel, entertainment, and portraits often intersects with the food world, and he greatly enjoys its rewards and challenges. Having shot for numerous magazines, including *The Food Network Magazine, Nest, Better Homes & Gardens*, David's images evoke that beautiful, natural-looking light that makes the viewer envious of those captured within them.

Creative challenges

David often finds himself styling when shooting travel stories, and missing his studio stylists, as he says, "especially when the food you're photographing is less than perfect. When you're used to photographing beautifully styled food with great choices of props, it really forces you to be creative when you're in the Republic of Georgia and the food you're meant to photograph comes out not looking its best, or most appetizing, and on plastic plates."

Preferred lighting

When David lights a scene, he is always attempting to create a natural feel. "You can't beat natural light. There's something about the quality of it that I've always been very drawn to." When using studio lights, David uses the Profoto Acute system. "I like to use a Profoto head with an umbrella, an umbrella sock and shoot that through a 4 x 6-foot (1.2 x 1.8 m) Scrim Jim with a full stop silk."

The future

When asked about the future of food photography, David says: "I really love seeing how photographers are adapting to video. I've been shooting a lot of video myself and I can see enormous potential in shooting food with video for both instructive—how-to—material as well as in more evocative ways."

More of David's work and insights into recent shoots can be found on his blog: www.davidaland.com.

Case study: Recipe photography

PHOTOGRAPHER: David Land

STYLIST: John Besh

CLIENT: *Food Network* magazine

USE: Editorial

LIGHTING: Mixed daylight and strobe

CAMERA: Canon 5D

LENS: 85mm L

This photographic series of John Besh for *Food Network* was shot to demonstrate how to bake oysters with wild mushroom ragout and aioli to accompany an article. In addition to capturing a great portrait of John, the article needed a series of step-by-step images and a beauty shot of the finished dish. The oysters were prepared and styled by John, following the recipe, with the help of an assistant.

Unlike a typical commercial studio shoot, there wasn't much room for error with these shots. The grocery supplies were limited, and didn't allow for many retakes if the food didn't look perfect. David and the crew had to move quickly once John plated the oysters to make sure that the lighting looked good for the finished dish shot.

To capture these shots, Land used a Canon 5D and 85mm L-series lens. A 12 x 12-foot (3.5 x 3.5 m) full stop silk was placed at an angle to the subject to the right of the camera with two side-by-side Profoto heads with reflectors and umbrella socks behind. A 4 x 6-foot (1.2 x 1.8 m) Scrim Jim with a white reflector was placed to the left of the camera. Land took advantage of the daylight coming in through the window behind the subject and adjusted the strobes to balance with it accordingly.

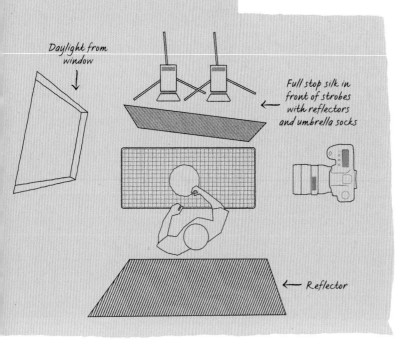

Daylight from window

Full stop silk in front of strobes with reflectors and umbrella socks

← Reflector

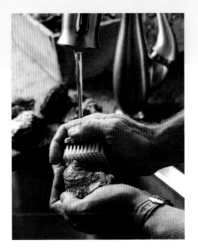
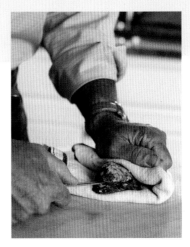
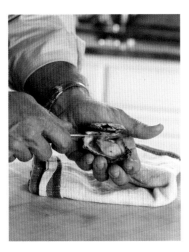
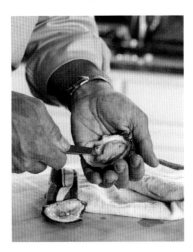

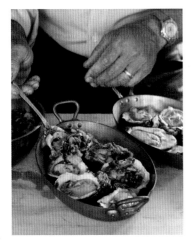
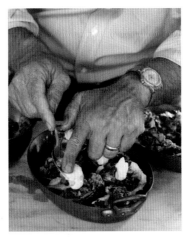

Noix de coco

Pain d'épices

Fleur de sel

Whisky

Photographer profile: Keiko Oikawa

The advent of food blogging has opened all manner of doors in the world of food photography and styling. The ability to self-publish to a worldwide audience has given professional food photographers a new way to showcase their work, and helped the world to discover talented, aspiring photographers who have the motivation to transform themselves from amateurs into pros. Keiko Oikawa is one of these. Her food blog, Nordljus (www.nordljus.co.uk), has garnered huge praise for its striking yet poetically quiet photographs in the six years of its existence. Her love of both food and photography is clear in each meticulous post, where every detail is thoughtfully captured in dish after beautiful dish.

Styling and lighting

Like most food bloggers, Keiko undertakes all her own food and prop styling for her personal work, and on occasion for her commercial clients as well. However, since she's moved into more commercial work she has come to appreciate the collaborative process of working with a stylist, particularly on larger shoots. Working with other creative people, she says, leads to even better images.

Keiko's distinctive style—bright with just a hint of poignant moodiness—comes largely from her use of natural light. She notes: "It's much easier to try different angles, moving both the camera and the subject. Natural light can be tricky as it's constantly changing, but I think it is very much part of my style."

On location

While she produces most of her food blogging work from home, Keiko's commercial work has taken her to some far-flung locations. Working on location can be a challenge, particularly, as she says, "when I don't know in advance what kind of situation I'll need to deal with. Recently I worked at a restaurant in a new hotel—the whole place was still a building site and we couldn't even find the way to the kitchen. Luckily the chefs did a great job preparing dishes on site."

Having a great camera bag is important when working on location, and Keiko says her bags are among her favorite pieces of equipment. "I love my camera bags—I bought them when I went back to Japan a few years ago from Artisan & Artist. They have many useful pockets, well thought-out design features, and look smart and professional without looking like a camera bag—perhaps because Artisan & Artist started out by making bags for makeup artists."

More of Keiko's work can be found on her online portfolio: www.keikooikawa.com.

Case study: Blog photography

PHOTOGRAPHER: Keiko Oikawa

STYLIST: Keiko Oikawa

CLIENT: Self

USE: Blog (editorial)

LIGHTING: Available

CAMERA: Canon 5D

LENS: Tamron 90mm macro

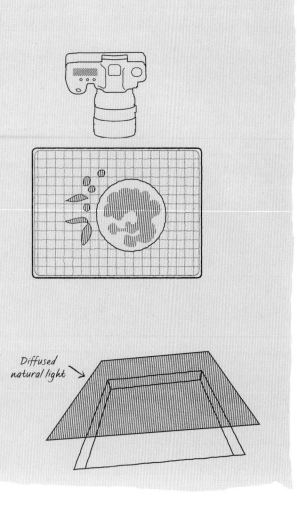

Diffused natural light

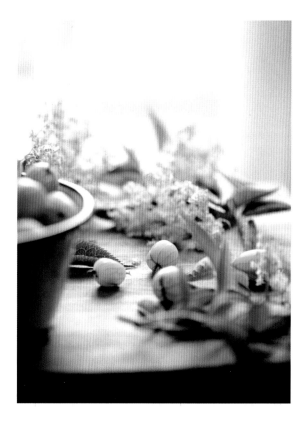

Shots that appear random always seem to be the ones that take the most effort. For this simple ingredients shot for Keiko's blog, Nordljus, she carefully arranged the elements to look as casual as possible. "The subjects were gooseberries and elder branches just picked from my allotment. Rather than putting them into bowls and so on, I thought I could show the 'freshly cut' feel just by scattering them on the kitchen worktop. I wanted to focus on the gooseberries, but I also wanted to have some perspective, so I arranged the elderflower at the front and back."

The simple backlighting creates a beautiful glow in the gooseberries, and the limited color palette of green, brown, and white adds to the beauty of the simple styling, creating another of Keiko's signature "moments." The viewer can't help but want to be part of the scene.

Case study: Cookbook photography

PHOTOGRAPHER: Keiko Oikawa

STYLIST: *The Foodie Bugle*

CLIENT: Editorial

USE: Editorial

LIGHTING: Available

CAMERA: Canon 5D

LENS: Canon 100mm macro

Daylight from window

Photographs such as this snapshot of how to make homemade pasta look deceptively simple. The lighting is direct window light, without even a fill card; the camera is handheld. The styling is simply done by the food writer, who prepared the pasta as the recipe is written. The shot is taken on location at the food writer's house.

The magic comes in recognizing just the right moment to shoot, and being in just the right position to capture it, as Keiko has done here. Experimenting with different shutter speeds to attain different levels of motion blur, and the appropriate level of contrast between light and dark, she manages to communicate the lightness of the pasta. "I liked the atmosphere that the strong contrast and the movement of her hands implied."

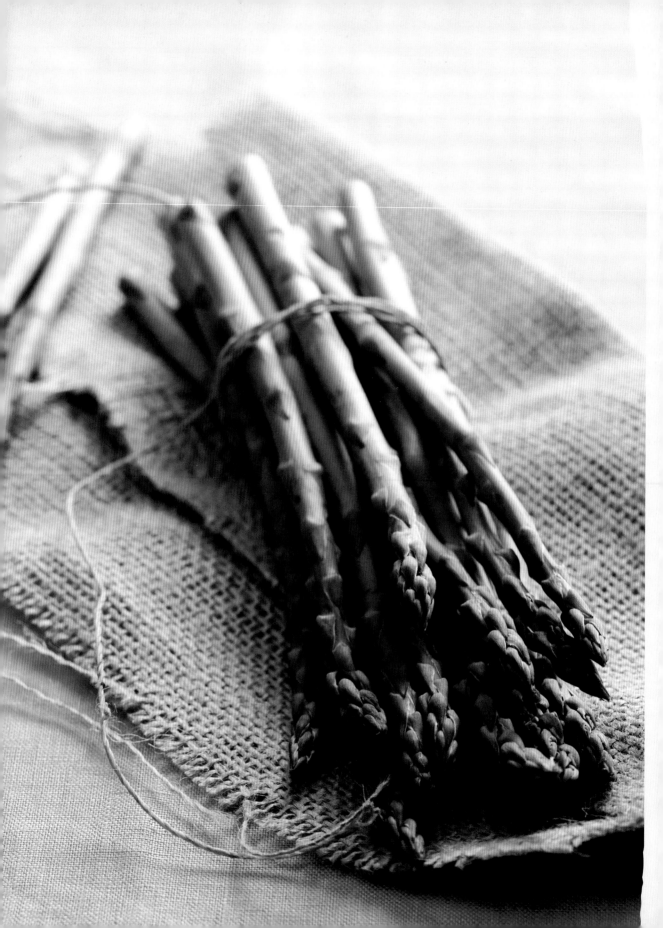

Photographer profile:
Todd Porter & Diane Cu

Todd Porter and Diane Cu began their professional photography careers working together as event and portrait photographers. Food was simply a hobby, with the quick point-and-shoot snapshot taken and seen by no one but the couple themselves. In 2008, however, they started to share their love of food and travel with the world on their very popular blog, WhiteonRiceCouple.com, which quickly opened new doors for them to begin shooting for editorial and commercial clients.

Known almost as much for their lush California garden teaming with produce year round and festive dinner parties, the two are just as comfortable cooking and styling as they are photographing food, and they often food style as well as shoot on assignment.

Recently, the couple have made a push into creating short videos for clients as well as providing still shots, and find themselves at the forefront of the food-related DSLR video movement after creating video trailers for several new cookbooks and food providers.

The two bring elegant simplicity to all their work, opting for natural light when available and unique props that add character to the story they are telling. "We expect to see a lot more artistic, fine art style of food photography emerging due to all the new technology of editing and post-processing effects."

More of Porter & Cu's work can be found on their website: tdphotographers.com

Case study: Promotional video shoot

PHOTOGRAPHER: Todd Porter & Diane Cu

STYLIST: Hasty Torres (client)

CLIENT: Hasty Torres/Madame Chocolat

USE: Marketing Materials

LIGHTING: Indoor florescent/mixed

CAMERA: Nikon D300

LENS: Nikkor 50mm, 85mm, and 24–70mm

VIDEO: www.madame-chocolat.com

This promotional video, for Hasty Torres and her chocolate factory in Beverly Hills, Madame Chocolat, shares a little of Hasty's story. Capturing her personality was key to really showcasing what Torres' shop is all about: smart, serious and dedicated to great chocolate, while still being fun, fabulous and sexy.

Keeping things light, the video focuses more on the personalities of Hasty and her husband Jacque and the playful aspect of working with chocolate equipment. Many of the scenes were improvised by Hasty and Jacque, so Todd and Diane weren't quite sure what was going to happen next. To allow for the greatest flexibility in shooting without dampening the lively energy, Porter and Cu opted for available light (mostly indoor fluorescent lights) and minimal photo equipment, and swapped off between one person directing and setting up the shots while the other handled the audio and video recording. The entire piece was shot with Nikon D300s, using the Nikkor 50mm, 85mm, and 24–70mm lenses.

When working with DSLR video, audio can often be a struggle. For this trailer, Porter and Cu recorded the voice-over track with a Sennheiser lapel microphone, plugged into a Zoom H4 digital recorder that backs up the audio track as well as feeds the audio directly to the camera's video files. A second camera was also equipped with a Rode Video microphone to allow for recording a secondary audio track, making syncing much simpler.

Final Cut Pro was used to color grade (to compensate for the variable lighting) the final video, as well as to cut it together. The two also use the Plural Eyes plugin to help with the audio synchronization.

Since the finished chocolate confections were prepared before the shoot, styling was kept very simple and focused mostly on Torres working (and playing) with the melted chocolate. The only propping involved was making sure everything was in its place and that any melted chocolate used was not too messy.

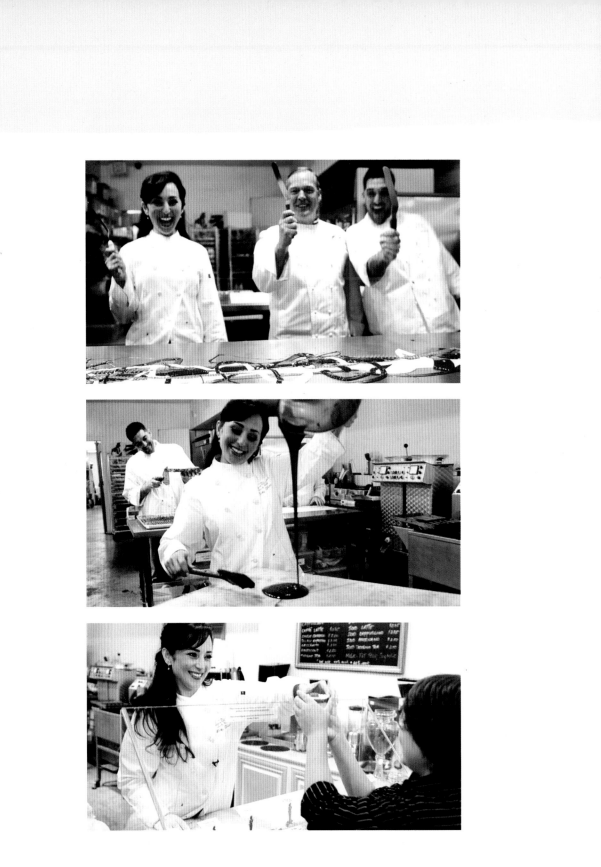

Photographer profile: Sara Remington

Pick up any popular cookbook these days and there is a good chance that Sara Remington was the photographer. Although she's been shooting food only for about four years, she's taken the editorial food world by storm. With some 25 photographed cookbooks in print, and more on the way, Sara sets the stage for other food photographers with her earthy and colorful approach to the subject.

"I got started in food photography by experimenting with fruit and vegetable still life in the kitchen of the small apartment I lived in at the time. I never set out to shoot food, to be a food photographer. I wasn't even a food photographer's assistant. I had more of a conceptual style, and was

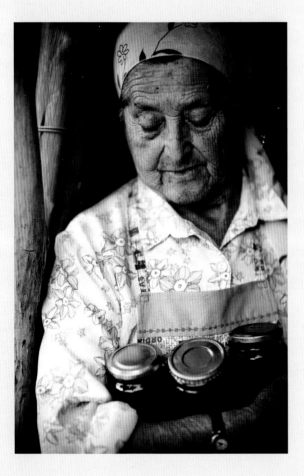

determined to be either an art photographer or travel-photojournalist." Even today, Sara shuts out outside industry influences, instead focusing on the life of whatever it is she is photographing. "I never collected other food photographers' portfolios for inspiration or to mimic their work. I gravitated toward painting, sculpture, and film; I worked in art galleries and learned about light, color, and story."

"After a friend saw a few still-life images of mine, he passed them onto a picture editor at a small magazine in Napa, California, who then gave me my first story—which turned out to be eight pages and a cover! The story was about chefs working in Napa who make daily trips to the farmers' market to purchase the best and freshest possible ingredients. I then, slowly, learned to respect food, to look at it not just as food, but also as sculpture with a story to tell. From this point, I started to build a specific food portfolio, which took years."

Stylists

Sara gives high praise to the authors and stylists she works with. "If there's a budget for food and prop stylists, absolutely, I completely believe in collaboration. It's just as much a food and prop stylist's image as it is mine; my images are only as good as the stylists I work with."

Lighting

Sara's images are driven mostly by natural light. "I'm spoiled in California where the sun is so abundant," she says, "so my thought is, what's the point of covering up gorgeous, natural light only to try and mimic it again in studio? I feel that artificial light limits the photographer to a small shooting space, doesn't allow you to be free and move around, to shoot from the hip. It is much more fluid to block and bounce natural light, to move and work with what you have. If I'm in a bind and I'm losing light, occasionally I will supplement natural with daylight-balanced Kino Flow lights."

Future trends

Sara's images are all about making food look approachable, rustic, and a bit of a "neat mess—like you can eat the food right off the page." She sees this trend continuing. "Crumbs, drips, bites, the use of butcher/parchment paper—these are all things that are successful. I don't see this approach changing all that much because it is such a huge part in making the food feel particularly real and very approachable.

"People are also craving a story with their food—where does it come from, how is it made, who eats it, why do they eat it, and so on? And this is a huge part of the future of food photography. We have an insatiable curiosity about what is in the food we eat, and the traditional photographic essay is an immediate and universal way of communicating a sense of place, along with the how and why of food."

More of Sara's work can be found on her website: www.sararemington.net.

Case study: Cookbook photography

PHOTOGRAPHER: Sara Remington

STYLIST: Erin Quon

CLIENT: Viking/Penguin

USE: *Wild Table* cookbook

LIGHTING: Natural light

CAMERA: Canon 5D Mark II

LENS: Canon 100mm macro

Successfully capturing a big hunk of meat is always a challenge, and with this shot for the *Wild Table* cookbook, Sara used natural light from a small window in a home kitchen with just a bit of bounce from a silver reflector to bring out the delicious nuances of the dish.

The overall shoot consisted of about 30 different plated dishes, all shot in either Erin Quon's studio or Sara's home kitchen. This particular dish—pork with cabbage and juniper berries—was created by Erin and her assistant. While Erin worked on the pork, her stylist prepared the sides.

Post production consisted of just some basic bumping of levels and contrast to make the image a little more saturated. This took about 20 minutes.

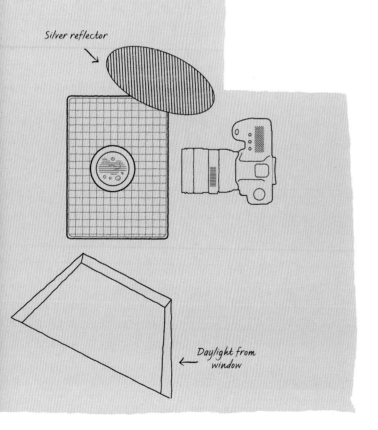

Silver reflector

← Daylight from window

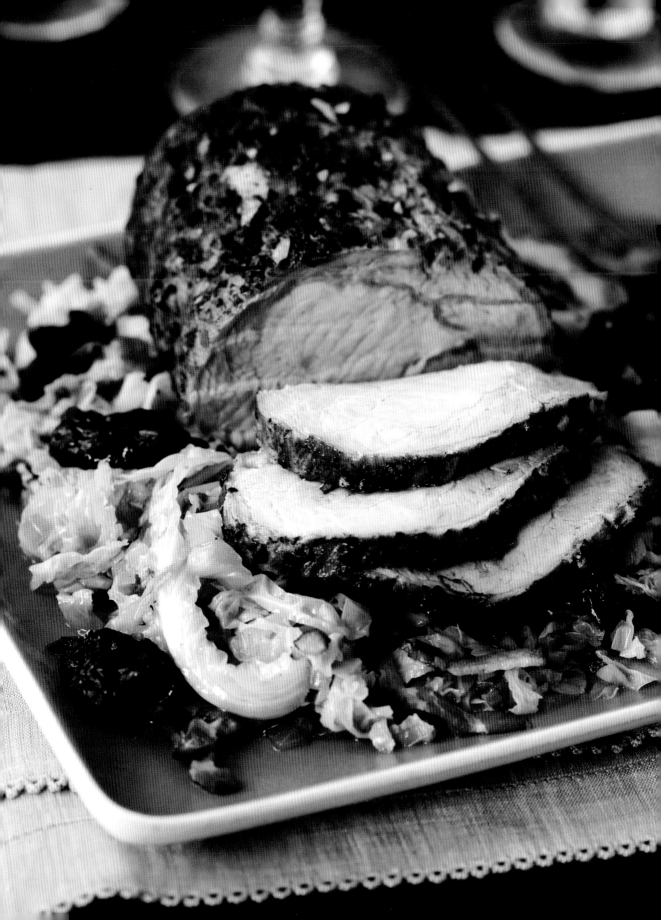

Case study: Magazine editorial

PHOTOGRAPHER: Sara Remington

STYLIST: James Syhabout (chef)

CLIENT: *SanFrancisco* magazine

USE: Restaurant feature on Commis

LIGHTING: Natural light

CAMERA: Canon 5D Mark II

LENS: Canon 50mm

This beet soup image, for an article in *SanFrancisco* magazine about Commis—a fine-dining restaurant in Oakland, California—showcases the art-inspired food of chef James Syhabout. Sara was excited by the dish's ingredients—small local vegetables and edible flowers. "Shooting this plate was like shooting a painting—the gorgeous color and attention to detail."

The styling and setup were kept very simple, with only Sara, her assistant, and the chef working together to create the shot. The chef did all of the styling, but Sara brought tweezers, q-tips, and some other basic essentials in case there were any drips on the plate. She used a window from the front of the restaurant as her key light source, with only a small 10 x 10-in (25 x 25 cm) foam-core bounce to bring out the color and detail in the shadow. The white walls in the restaurant added to the overall brightness of the image and evened out the lighting on the plate.

The composition of this shot was driven in part by the beautiful dish itself, and in part by the magazine layout. Extra white space was left at the top of the image to allow for possible cover usage, leaving room for text.

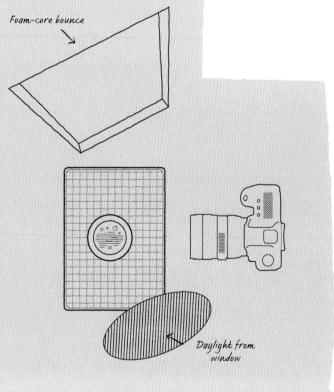

Foam-core bounce

Daylight from window

Case study: Marketing

PHOTOGRAPHER: Sara Remington

STYLIST: Kim Kissling

CLIENT: Grand Lux

USE: Marketing materials

LIGHTING: Strobe

CAMERA: Hasselblad H1 plus a Phase One digital back

LENS: Hasselblad 120mm macro

"A big, delicious, drippy, mouthwatering pile of pancakes," is what Sara was going for when her client, the Grand Lux restaurant (a partner of the Cheesecake Factory), asked for a representative image from their breakfast menu "like a gorgeous pile of shiny, sharp jewelry."

To achieve the look, Sara had to move away from her typical natural-light setup, and instead used strobes to the rear on both the left and right sides of the stack, as well as an overhead to catch additional highlights. She also positioned the camera a little below the stack, and tilted the lens up to make the rise of the stack look even more dramatic, and kept most of the image sharp with an aperture of f/13.

The in-house chef prepared the pancakes, and a food stylist plated the stack and poured the syrup to achieve the gorgeous drips. However, a single shot didn't exactly capture the image to perfection, so the drips themselves came from three different shots, layered together in post production. The client was able to specify which drips he liked best to create the final image.

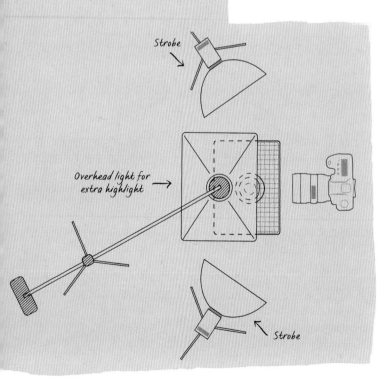

Strobe

Overhead light for extra highlight →

Strobe

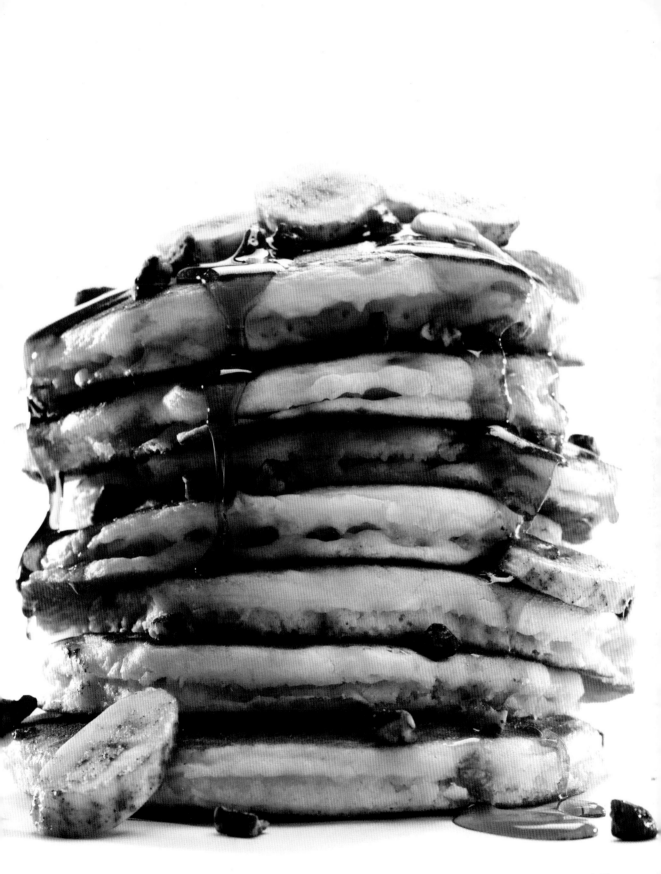

Photographer Profile: Valery Rizzo

Valery Rizzo has had a life-long interest in food, health, cultures, and traditions, but she began photographing food only about four years ago after joining a food co-op in Brooklyn, New York City. The organic produce inspired her and made her realize how special food can be. With a background in design—she worked at Ralph Lauren Home Collection for 17 years—she brings a strong sense of color and style to her work, and typically styles her own food and props.

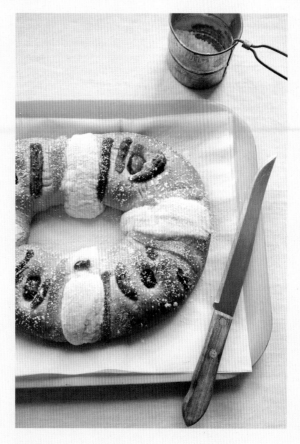

Agency work

Although Valery shoots assignment work, a large portion of her business focuses on stock photography. She has an extensive portfolio, managed through various agencies, including Getty Images, Corbis, Jupiterimages, Botanica, Workbook Stock, FoodPix, BrandX, PhotoDisc, The Image Bank, and Alamy, with images ranging from apple picking to zucchini flowers.

For more of Valery's work, see her online portfolio: www.valeryrizzo.com.

Case study: Stock photography

PHOTOGRAPHER: Valery Rizzo

STYLIST: Valery Rizzo

USE: Stock

LIGHTING: Available light

CAMERA: Vintage SX-70 Polaroid

FILM: Polaroid 600

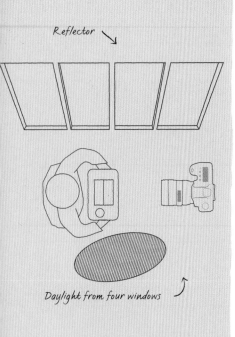

Reflector

Daylight from four windows

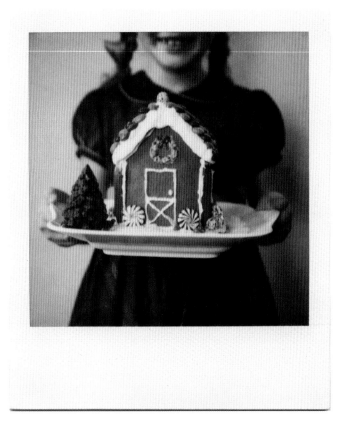

The subject here was the homemade gingerbread house; the goal was to include part of a person—the little girl dressed very traditionally in a Christmas outfit—to add a human element and give the shot more of a story. By using a vintage Polaroid, Valery gives the image a fun and rather stylized look that makes it stand apart from most stock food photographs.

"Here I was both the food and prop stylist. Styling included deciding what was needed to decorate the house, the dish the house would sit on, choosing the model, what the model would wear, and what the background would be. My inspiration for the shot was a charming gingerbread house kit from Germany I found in a shop in Brooklyn. The kit intrigued me and gave me the idea of building the shot around a kit and the whole process of using one."

Case study: Stock photography

PHOTOGRAPHER: Valery Rizzo

STYLIST: Valery Rizzo

USE: Stock

LIGHTING: Available light

CAMERA: Nikon D300

FILM: 17–55mm

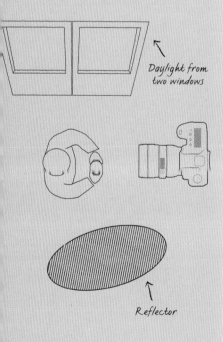

Daylight from two windows

Reflector

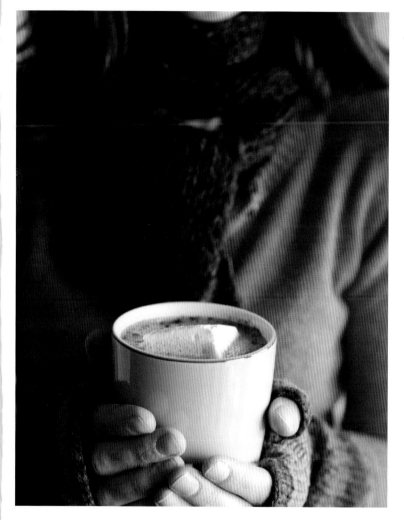

In this shot Valery wanted to communicate warmth and contentment contrasted with the coldness of winter. The gloved hands cradling the hot cocoa conjure an image of coziness. Including the human element also helps to make this a great stock shot. Styling included making sure that all the colors of the clothes, cup, chocolate, and marshmallow complemented each other. "The biggest challenge was keeping the marshmallow from melting too much. I wanted it to remain looking fresh and desirable, but at the same time I wanted a bit of frothy goodness. I made about two to three different cups of hot cocoa and tried floating the marshmallow in warm rather than boiling hot liquid to control the degree of melting."

Case study: Stock photography

PHOTOGRAPHER: Valery Rizzo

STYLIST: Donna Block

USE: Stock

LIGHTING: Available light

CAMERA: Nikon D300

LENS: 17–55mm

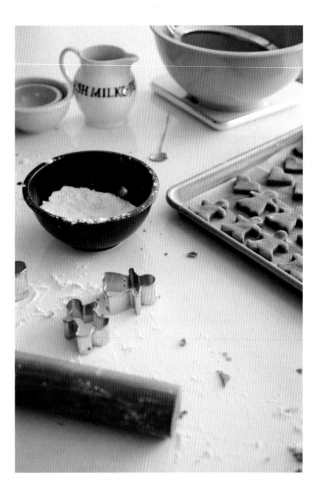

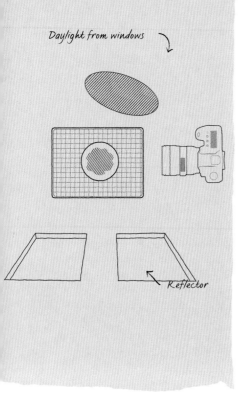

Daylight from windows

Reflector

The subject in this process shot is the kitchen preparation area, where gingerbread dough is being rolled and cut into cookies. The goal was to keep the shot looking as real as possible while still maintaining a commercial look and styled mess. Valery says her inspiration for the shot "was the two cookie cutters in the foreground, which I felt said gingerbread-man and -woman. I loved the play of the clean, white counter and modern props against the messy prep area."

"For this shoot I worked with cake artist Donna Block, who baked everything while I shot her working in real time. I tried to use all of the props that she already had on hand in her kitchen. Lucky for me Donna had her own sense of style, which you can see in the props and creativity that she brought to the shoot. I just removed or moved things around to my liking."

PHOTOGRAPHER: Valery Rizzo

STYLIST: Donna Block

USE: Stock

LIGHTING: Available light

CAMERA: Nikon D300

FILM: 17–55mm

Daylight from four windows

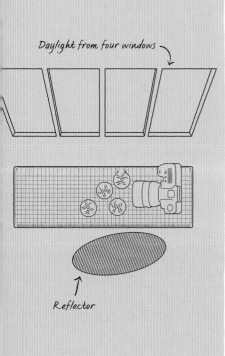

Reflector

These cupcakes were prepared to serve at the NYC Punk and Underground record fair. The wording "eat me" happened to have a fortunate double meaning—one for the punk-rock crowd; and one for other food lovers. Valery took quick advantage of this for her stock food portfolio. Being so close to Christmas, stylist Donna Block chose to place gingerbread people on some of the cupcakes, which made these images fit well into the seasonal theme.

Stylist & photographer profile:
Lisa Golden Schroeder and Dennis Becker

Lisa Golden Schroeder, Prop & Food Stylist

Long-time stylist Lisa Golden Schroeder started working in the food business in corporate test kitchens. She holds degrees in nutrition/food science and journalism as well as an advanced diploma from culinary school, where she had her first experiences as being a part of a food photography shoot. She found she had an eye for composition and a meticulous nature when it came to presenting food. In 1985 she began styling as a food editor for a cookbook publisher, where she developed the recipes and styled for the in-house shoots. In 1987 she struck out on her own, taking on tabletop propping as well as food styling, eventually focusing her business more strictly on food photography.

Stylist's toolkit

Lisa has amassed quite the stylist's toolkit over the years. She calls it a bit of an obsession. But she does still have a few favorite everyday tools: "my long tweezers—straight tips and about 7in (18cm) long)—a needle-nose dropper bottle for water, and a narrow-tipped grapefruit spoon that's perfect for applying sauces. I do love my old stovetop grill that I've nearly burned through as it gives the most interesting char marks to 'grilled' veggies or chicken. I really don't have anything that's super out of the ordinary because really, for many jobs, having dexterous hands and a sharp mind are the best assets stylists have!"

Overcoming challenges

Lisa finds meats to be very challenging, as often they are not as appetizing on "film" as in real life. "I don't eat a lot of meat, so I find myself researching and experimenting if I have to photograph something I rarely come across—such as a standing rib roast that needs to be sliced, as well as achieving just the right 'doneness' if the meat has to be cut up. Other types of food that change quickly are also always a challenge—finding that perfect dance with the photographer so we capture exactly the movement or moment that tells the most interesting story about the food."

"I like the feeling of telling a story about food or a recipe, putting it into some kind of context or giving it some history. Food is about culture, relationships, community, and props can really make or break the storytelling behind a food image."

Future trends

"It's likely that the current trend for getting in tight on food, really bumping up the appetite appeal in a simple way, will continue. But 'lifestyle' is the buzzword these days—and with the rise of social media and how we need to communicate with our audiences, there will be more photography that embraces where and how food is grown, made, and eaten—as part of a larger context. And, of course, there's food in motion—videos about where food comes from, how to prepare it, and its role in our daily lives is only going to become more and more important. Food apps for smart phones and tablet computers are exploding—so maybe more images that are very simple and easy to 'read' in small format might affect how we compose and shoot food, along with step-by-step photos that teach people more about cooking."

For more on Lisa Golden Schroeder and the food-styling industry, see her website: www.foodesigns.com.

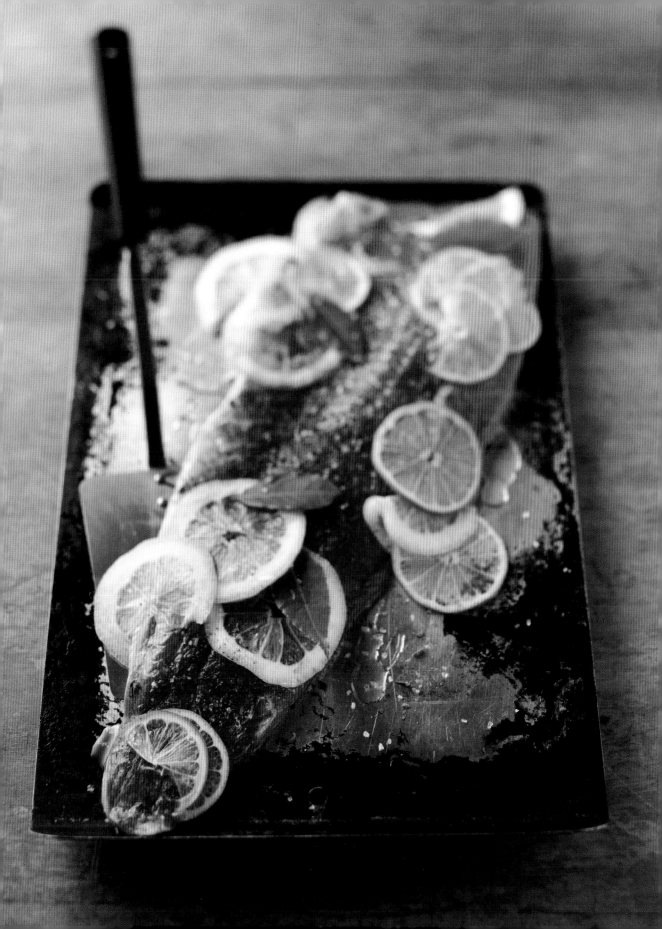

Dennis Becker, food photographer

After college, where he majored in photography, Dennis Becker went to Minneapolis in 1985 to look for work in commercial photography. "I started assisting in a studio that shot a lot of food as well as product. My interest grew in food versus product as I felt that working with a food stylist as well as an art director was more creative and more of a team effort."

Early days

After freelancing for several years, Dennis decided to focus on food, and took a staff position at the global food manufacturing giant, General Mills. "This was a good experience for me— shooting food every day for five years helped teach me a great deal about food photography."

Changing styles

Dennis has seen a lot of change in
the industry during his time. "Food
photography in the 1980s had a
definite style—black backgrounds,
perfect food, and images that were
tight and sharp. Then the Australian
style came in, which was more soft-
focus light backgrounds and real food
that is not perfect, sometimes a little
burned on the edges, with crumbs—
messy in a good way is where you get
appetite appeal."

Career development

Dennis left General Mills in order to develop greater diversity in his work and to
have more freedom to adopt different styles of photography. "I like to use props that
have a lot of character. I like to showcase the food more artistically versus what would
make total sense. In other words, looking at color and texture and creating a pleasing
visual composition, but one that is, above all, appetizing."

Dennis is currently working exclusively for a studio in Minneapolis with two other
photographers. The studio specializes in food and he frequently works with stylist
Lisa Golden Schroeder. His online portfolio can be found here:
tkpinc.com/DENNIS_BECKER_PHOTOGRAPHY/index.html.
(Please note that this web address is case sensitive and must be typed in as shown.)

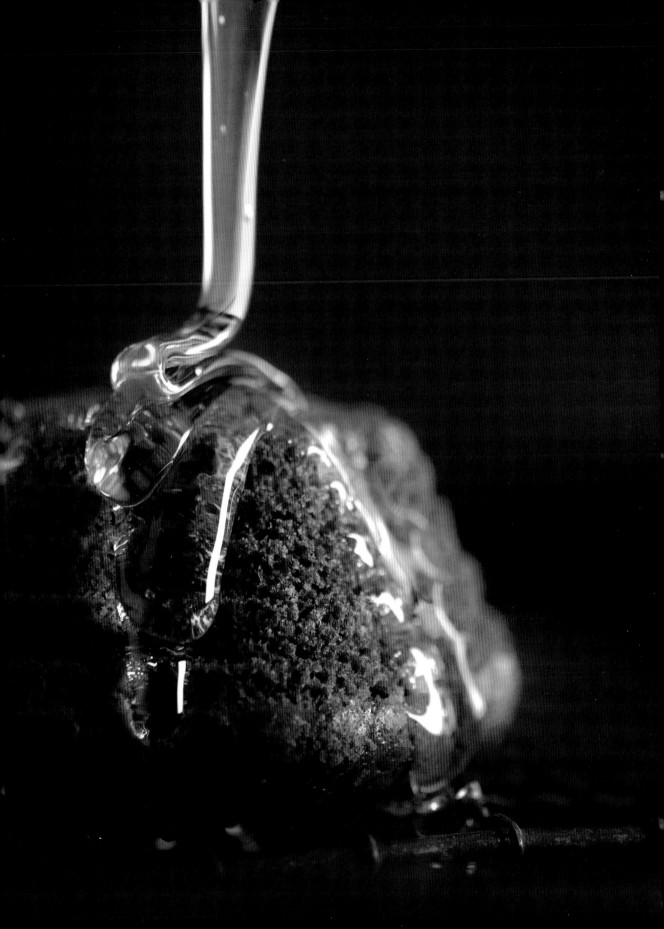

Case study: Poultry recipes

When the subject is fresh chicken, food stylists and photographers have to get creative. For this project, food stylist Lisa Golden Schroeder was hired to create a line of recipes for the company—a group of chicken producers working on small family-run farms. Communicating that the poultry was as close to organic as possible—without the lengthy and bureaucratic process involved with certification—and traceable, so consumers could find out where their chicken was raised, were key to the message. The target audience is considered very conscientious and careful about what they buy and feed their families. They are also considered to be knowledgeable about food and cooking—and sophisticated about cuisines and flavors.

One thing leads to another

The recipe development quickly turned into a photography assignment for packaging and then general marketing materials. Lisa brought in Dennis Becker, a photographer she'd worked with on quite a few projects. "We began working in a very safe way, with our first shoot resulting in nice, but not particularly compelling shots. The client liked them, so we began to push the limits with each shoot. We never work with an art director, but Dennis has a wonderful sense of composition and we have a very easy way of collaborating—we both know it when we've got the shot. Dennis's studio has an impressive prop room, so we rummage around to find the props to use." Lisa and Dennis worked closely together to decide on the props, often starting well before the shoot and taking a quick iPhone snap to remember a particular prop discovery.

Working from the recipes that Lisa had developed, the styling for these chicken shots came naturally. Although the shoot was for commercial use, Lisa and Dennis followed more of an editorial process, working quickly and not overworking the food. Lisa says: "I almost never do a stand-in, as it does make lighting harder—Dennis would get interesting lighting established and it would all change if I then brought out different food. So the 'dance' under camera is very defined—we communicate well so we both know exactly where we are at all times.

"We do think carefully about what the best moment in a food product's life is—do we shoot an individual serving—so we can get in very close on the food—or is it before the food is even cooked? The casserole shot of the whole cut-up bird with citrus is a good example—we shot it raw, because we thought it was beautiful at that point. Then I popped it in the oven and actually baked it in the casserole."

PHOTOGRAPHER: Dennis Becker

STYLIST: Lisa Golden Schroeder

USE: PR and marketing materials

LIGHTING: Strobe

CAMERA: Hasselblad with
a Leaf Digital back

LENS: 100mm

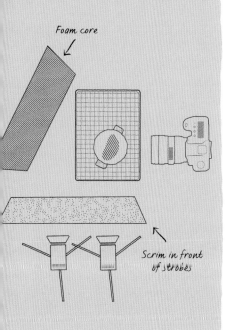

Foam core

Scrim in front
of strobes

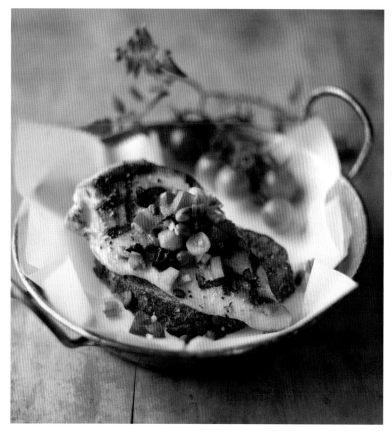

Grilled chicken

Even with garden-fresh ingredients and artfully applied grill marks, a breast of
chicken can look a little dull. In this shot, the crumpled parchment adds visual
interest and invokes a casual, outdoor dining feel. The small serving dish holds
the whole thing together in a unique and fun way.

To create the grill marks, Lisa sautéed the chicken in a skillet and used a grill tartar
and torch to complete the look.

Roasted chicken

PHOTOGRAPHER: Dennis Becker

STYLIST: Lisa Golden Schroeder

USE: PR and marketing materials

LIGHTING: Strobe

CAMERA: Hasselblad with a Leaf Digital back

LENS: 100mm

The challenge of this shot was to show a half chicken without the bird looking almost animated. Lisa Golden Schroeder says: "We played quite a bit with how to position the bird so it didn't look like it was going to run off the tray." The finished bird was placed on the set and rotated until just the right angle was found.

To get the warm, golden skin, Lisa roasted the chicken with the honey glaze in the recipe, and used a small torch to touch up a few spots. The plums were grilled on a tabletop grill, to complete the look. The parchment, loosely placed on the tray, again provides visual interest and separation.

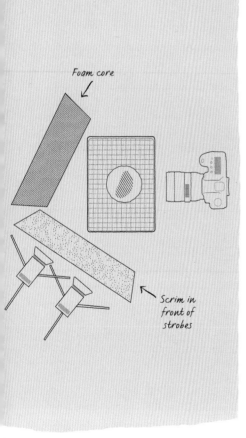

Foam core

Scrim in front of strobes

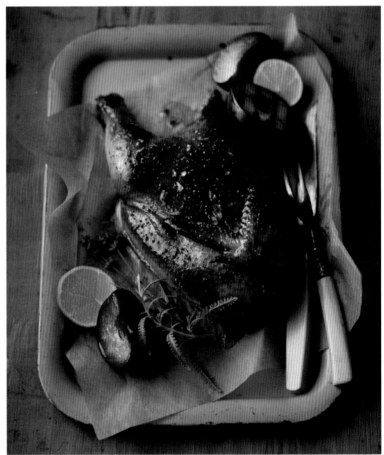

PHOTOGRAPHER: Dennis Becker

STYLIST: Lisa Golden Schroeder

USE: PR and marketing materials

LIGHTING: Strobe

CAMERA: Hasselblad with
a Leaf Digital back

LENS: 100mm

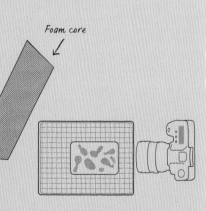

Foam core

Scrim in
front of
strobes

Raw chicken

For this roasted chicken dish, Lisa and Dennis took the unusual step of sticking with the raw ingredients, artfully arranged. The bright oranges play off the mint green color of the casserole, making the whole dish feel summery and fresh while still showcasing the chicken. Although you might not want to reach in and take a bite, the shot makes it feel simple to prepare and implies the delicious flavors that will soon be there.

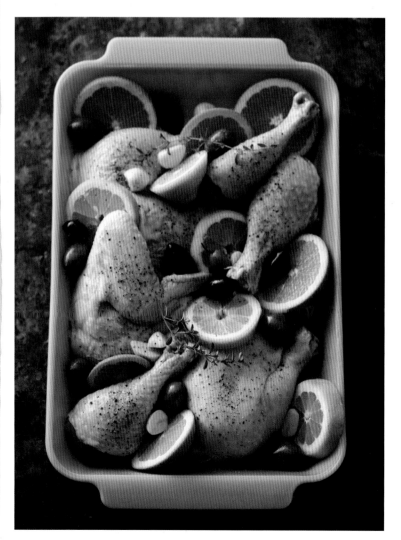

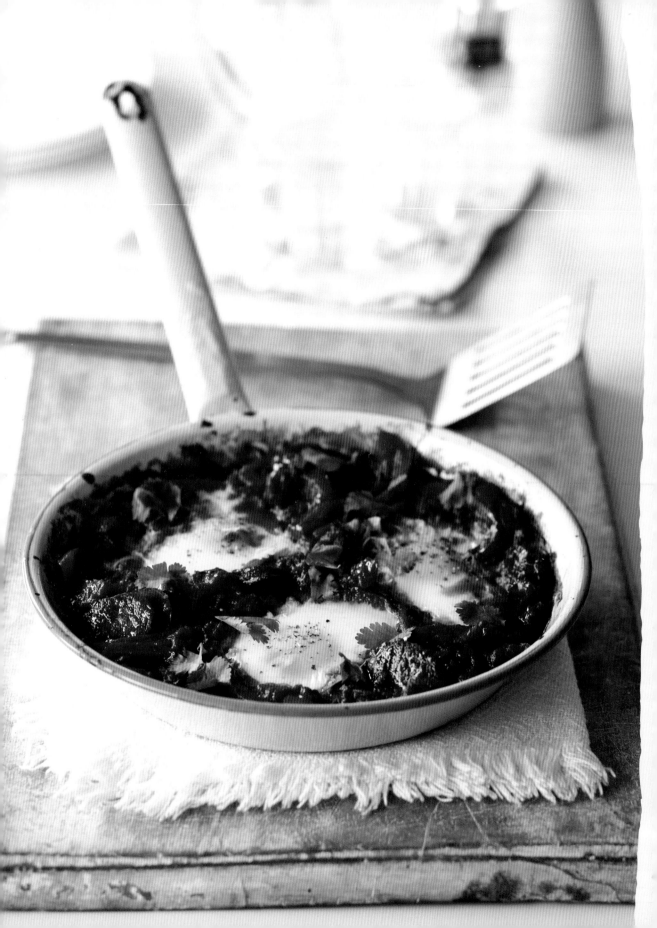

Photographer profile: Charlotte Tolhurst

Although Charlotte Tolhurst is relatively new to professional food photography, she has made an impact. After being inspired by a fellow photographer from Australia, Charlotte carried out some test shots with a home economist, and has been shooting food ever since.

Horses for courses

Like most food photographers, Charlotte leaves the styling to the professionals, but she plays an active roll in prop styling, either carrying out the work itself or pulling props from her own collection to help the prop stylist. Charlotte says: "I think that the props are as important as the food or the photography on a shoot and it is amazing how changing a napkin or a plate can make or break a shot."

Preferences

Charlotte's airy, natural style lends itself to shooting with natural light, which she says "makes the composition look lovely instantaneously. With flash you have to work a little harder to make things look natural and even then it is hard to emulate the quality of daylight exactly." But even with beautiful light, there are some subjects Charlotte prefers to avoid. "The trickiest dish for me would have to be chicken in a pale cream sauce, for example. It probably is subjective; others may have no problem with something like this. But I must admit I've never seen chicken in a cream sauce or vitello tonnato on photographers' websites promoting their work."

Evolving styles

"In the last few years we have seen more and more overhead shots and also messier shots with the emphasis on 'real food,' so perhaps in a few years we will swing back the other way to more perfectionist, aspirational photography. Who knows? It is for us food photographers to innovate and hope it catches on."

For more of Charlotte's work, see www.charlottetolhurst.com.

Case study: Stock photography

PHOTOGRAPHER: Charlotte Tolhurst

STYLIST: Charlotte Tolhurst

CLIENT: n/a

USE: Stock

LIGHTING: Natural

CAMERA: Canon 5D Mark II

LENS: 90mm T/S

Charlotte Tolhurst created this classic coffee-time shot as part of her stock portfolio. She used natural, diffused light with the camera high overhead, and slightly desaturated the image in post production to make a cozy, peaceful moment with a classic French feel.

Since the photograph is really about the feeling of this quintessential coffee-time moment rather than selling a cup of joe, Charlotte faked it using Barley Cup instead of real coffee. This gave it a beautiful *crema* on top that was able to hold up during the shoot.

Shooting from high overhead, this "coffee" moment was lit by daylight through a window behind, while a white card opposite and to the front threw back some illumination. An aperture of f/3.5 and a shutter speed of 1/100 second were used.

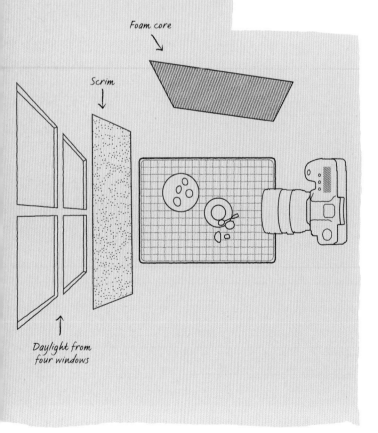

Foam core

Scrim

Daylight from four windows

Case study: Stock photography

PHOTOGRAPHER: Charlotte Tolhurst

STYLIST: Felicity Barnum-Bobb

USE: Editorial

LIGHTING: Natural

CAMERA: Canon 5D MII

FILM: 90mm T/S

Some shots take more effort than others. Initially, Charlotte Tolhurst was unhappy with this bowl of mussels. Although the shellfish themselves were appealing, the luscious jus was being lost. Turning the table so that the light was coming from the rear gave the broth and mussel shells a beautiful glossy light.

Here the camera was positioned at 45° to the subject. Natural daylight from a window lit the dish from the rear and a white card opposite bounced light back to provide details in the shadows. An aperture of f/8 required a shutter speed of just over half a second.

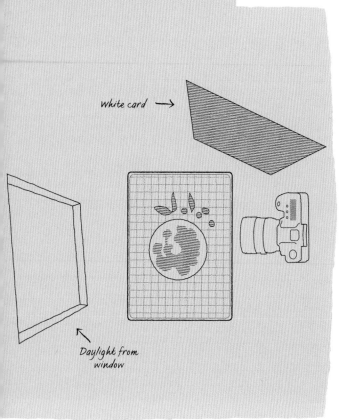

white card →

Daylight from window

Case study: Marketing

PHOTOGRAPHER: Charlotte Tolhurst

STYLIST: Charlotte Tolhurst

STYLIST: Kate Wesson

CLIENT: Alpro

USE: Marketing materials

LIGHTING: Natural

CAMERA: Canon 5D MII

LENS: 90mm T/S

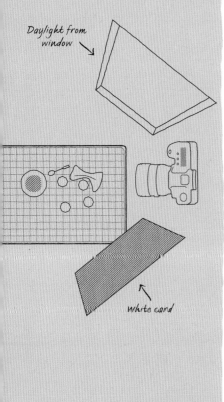

Sometimes the perfect shot comes along just by chance. For these soy parfaits and cranachan, Charlotte Tolhurst wanted an evocative, summery shot, since this dessert is traditionally eaten during the summer months. Just as she was about to shoot, the sun glinted off a window opposite and produced just the right specular highlight to give that all-important feel of summer she was searching for.

Taking advantage of those lucky light moments is an enormous part of being an available-light photographer.

With the camera at an angle of 45° to the subject, the window light was coming from the rear, right-hand side, while a white card was positioned on the left front side of the subject to return some of the light. An aperture of f/5.6 and a shutter speed of $1/13$ second were used.

Photographer profile: Johan Vanbecelaere

Growing up working in his parents' restaurant in Veurne, a historic town near the Belgian coast, Johan Vanbecelaere started his career in the kitchen rather than the studio. It was while attending Ter Duinen, a cooking and hotel management school, to "refine his chocolate mousse," that Johan discovered photography and fell in love with the mixture of art, science, and craftsmanship it represented.

Early days

Johan explains that for him, photography was somehow magical. "The magic, silence, and concentration in the darkroom were great moments for recovering from the often noisy clients and tourists in the restaurant business-cum-home," and this inspired Johan to attend photography school at Sint-Lukas College of Art and Design in Brussels, Belgium.

After working as an assistant, doing mostly corporate and product photography, Johan set up his own studio near Brussels, gaining as a client *Le Guide des Connaisseurs*, a gastronomy and lifestyle magazine. Being both a cook and a photographer was a major advantage for Johan's new studio, allowing him to do his own styling—a godsend when working on smaller-budget projects or on those with tight deadlines. Today, he prefers working with a stylist, but finds this is still sometimes a challenge in his market. "The choice is often made by the client. The good food stylists are very rarely here, and often you find yourself with a pro chef who does this beside his other work."

Film or digital

Johan's film and darkroom training shaped his early photography. Although now he works with a Phase One P45 back tethered to a 24-in (61 cm) display, and finds it faster and more controllable than film, he still misses "the magic of a 4 x 5-in (10 x 13 cm) ground-glass viewing screen and the excitement of seeing the slides on the light box. I find it harder to obtain the essential feel in a shot with all the technology involved."

Johan says: "That's where light comes in. My favorite attribute is a sheet of translucent plexiglass, and a worn-out cloth for random light spots. I love to work as minimal as possible."

For more of Johan's work see www.vanbecelaere.com.

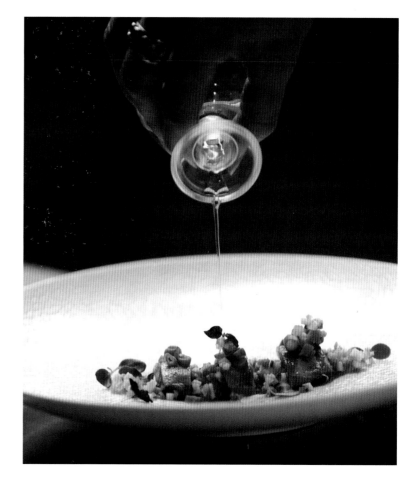

Case study: Stock photography

PHOTOGRAPHER: Johan Vanbecelaere

STYLIST: Johan Vanbecelaere

CLIENT: n/a

USE: Stock

LIGHTING: Mixed daylight and tungsten

CAMERA: PhaseOne P45 Digital Back

LENS: 120mm Macro

The most challenging shots are often those involving movement, and there are many ways to approach this type of shot to capture just the right splash in just the right light. To create a more natural look, Johan combined daylight with a studio tungsten light shot through a translucent milk-colored plexiglass for diffusion, capturing the pour and glass in a single shot. The red of the wine and the background work together to create a bright and colorful shot with a strong graphic presence.

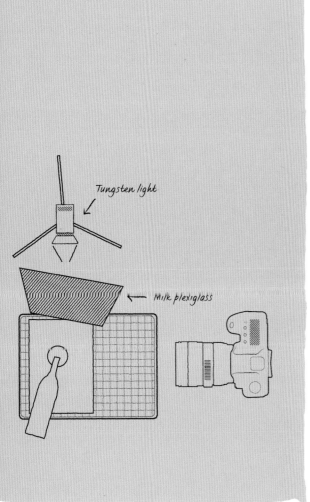

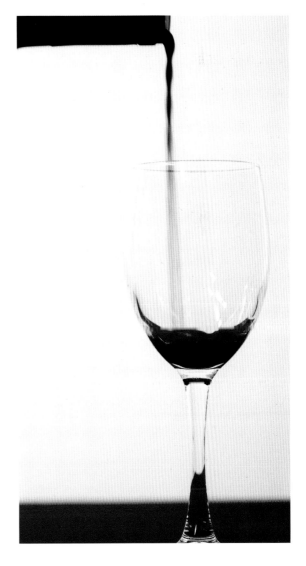

Case study: Stock photography

PHOTOGRAPHER: Johan Vanbecelaere

STYLIST: Johan Vanbecelaere

CLIENT: n/a

USE: Stock

LIGHTING: Strobe with daylight fill

CAMERA: PhaseOne P45 Digital Back

LENS: 120mm Macro

For a more controlled shot, Johan combined three separate images to create a powerful wine-pour image that would be nearly impossible to capture in a single shot. He began with a shot of an empty glass shot on a colorful, gradient-lit background. A single strobe with a beauty dish, shot through milk plexiglass for diffusion, softly highlights the glass.

Next, a series of pours is shot to capture the wine's movement in the glass. The wine is slightly diluted to allow more light to pass through to emphasize the color. The wine is lit with a snooted strobe backlight to freeze the motion. A beautiful swirl on the bottom of the glass is taken from one shot, while dramatic hand and bottle, the stream of wine, and the agitated surface come from another. When the three images are merged together, the clean glass image is used to mask off any splatter and drops.

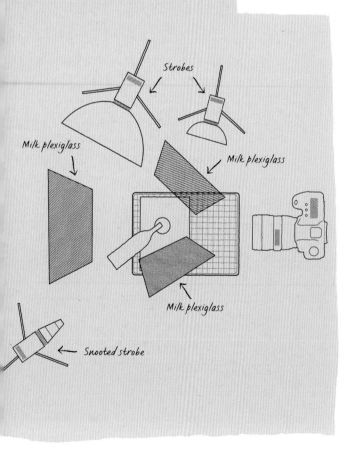

Strobes

Milk plexiglass

Milk plexiglass

Milk plexiglass

← Snooted strobe

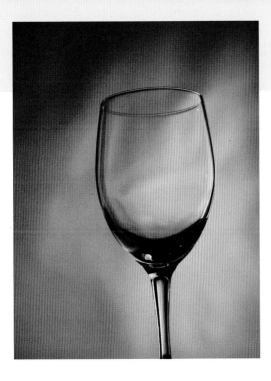 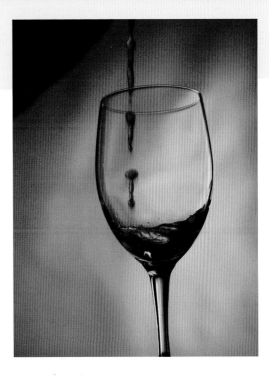

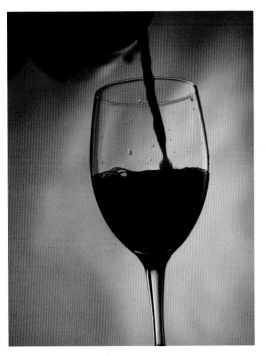 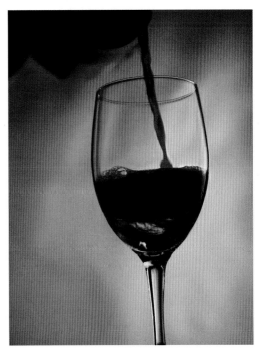

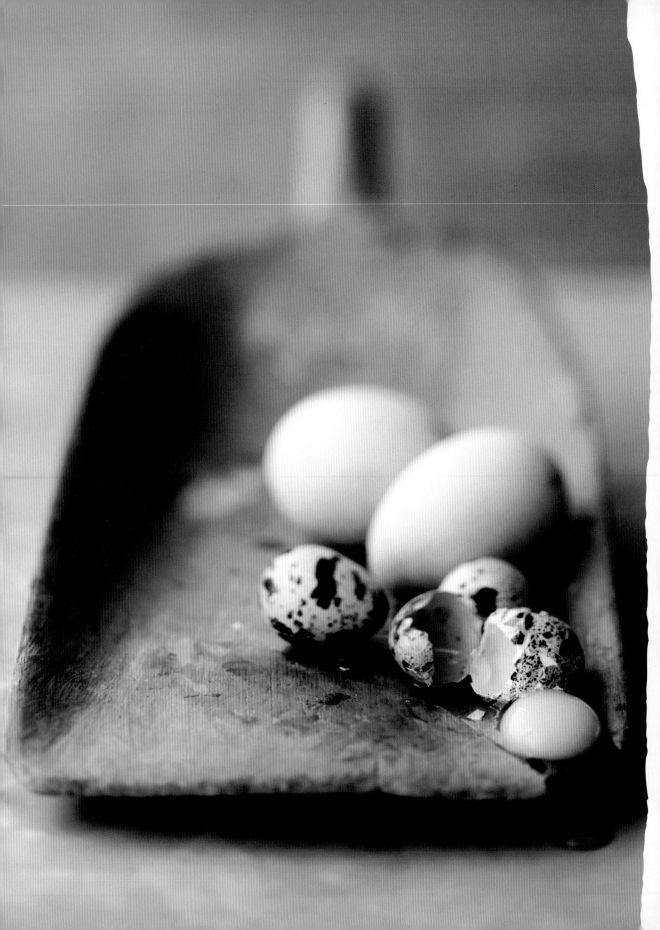

Photographer profile: Francine Zaslow

Francine Zaslow has spent the past 20 plus years working as a food photographer in Boston. Originally from Hartford, Connecticut, she spent her early years surrounded by a family of artists. Her mother, Jean, a sculptor, was Francine's greatest influence. "She was never afraid to experiment with different materials—paper, stone, wood, clay, etc. She was always trying something new," says Francine. "She inspired me to explore my own creative voice using a camera as my personal vehicle for self-expression."

Building a career

Francine went on to study at the University of the Arts in Philadelphia where she refined her skills as a photography major, studying light and form, shooting the figure, and delving into still-lifes. After graduation, she immediately got involved in commercial photography.

At the age of 24, Francine moved to Boston and began shooting with ad agencies and designers. Although she was building a name for herself as a commercial photographer, she continued to experiment, exploring and expanding upon her unique signature style, and staying connected to her "fine art" work. "It has always been a thrill when the two styles have merged together," she says. "Art directors would sometimes develop projects that sprang directly from my more vital, personal work."

In recent years, her client base has come to include a large number of companies in the food industry, such as Panera Bread, Au Bon Pain, and Whole Foods Markets.

Delicious form meets function

When photographing food, Francine relies on the talent of her food stylists to bring their expertise and culinary vision to the set. Working together, they find creative solutions that will meet the needs of her clients. "It's all about the subtle shapes, colors, and textures, and how the light wraps around the food, triggering our senses," Francine says. "We try to make the customer's mouth water by drizzling the sauce just so, or melting bright yellow cheese that oozes out of a sandwich, or by invoking a sense of refreshment with the condensation that clings to the side of a frosty glass. By focusing the viewer's attention on these delicious details, the consumer can almost taste the dishes—though all they're really experiencing is light and texture."

"In terms of lighting and composition, I'm able to use the same techniques employed for any other subject matter, but with food, I have a limited amount of time to get the shot exactly how I want it. I stay aware of the freshness, color, and vitality of the food, capturing a great image before time runs out. For most shots, I use a "stand-in" plate that allows me to work out compositional and lighting details. Once these details are resolved, I can then place the final, freshly plated food on set, make my final adjustments, and take the shot."

"I frequently use what is called 'one-point-focus,' where the focal point of the photograph is sharp, while the rest of the image fades out to give a soft, painterly look. The eye is drawn to that one sharp area and is held there to explore the details. Using subtle detailing and composition, I find new ways to take the viewer's eye into, through, and around the image, creating a flow or path that the eye is encouraged to follow."

Creating a soft background brings depth to the image and a relaxing, romantic softness to the visual experience. Sometimes Francine is able to create the illusion that the set goes on for a great distance, when in reality it's only a very shallow area.

A hands-on set

On set, Francine has a hand in everything from the fold of the napkins, choosing the backgrounds, designing the placement of the objects, and the mood of the lighting. Combining the expertise of the food stylist with the elements that the prop stylist brings to the set requires balancing and managing a team of creative people. "Together we share our vision, throw out ideas, discuss how best to layer the elements, how high to raise the level of the liquid, or whether the shape of the plate is proportionally correct for the shot."

Painting with light

For Francine, the lighting is crucial for producing the right feel and mood. Depending on how much natural light pours through her large bank of windows, she may use daylight to illuminate the set. A soft, sheer curtain may be used to filter light, or a strobe may flash through a diffusion screen looming over the set, setting a specific mood. "The goal is to be able to light the set in such a way that you can't tell the difference between natural or artificial."

Future trends

"A lot of food magazines are trying for a more realistic look, showing half-eaten dishes, crumbs on the plate, some sort of hint that action has taken place. A scoop might be taken out of a bowl of pudding, an ice cream may be starting to melt, the torn edge of a baguette may be used to define its texture. This is a positive trend in my opinion," Francine says. "When food looks too perfect, it starts to feel sterile and lacks that natural, organic aspect, missing the details that give your senses the cues they need to make your mouth water. I much prefer a shot that looks like someone just sat down to eat, juices spreading across a plate, showing me how moist and delicious a slice of tenderloin really is."

Francine will always identify herself first as an artist, staying deeply connected to her personal work where her imagination can run wild without commercial constraints. These pet projects often involve shooting "organic" shapes, distilling them down to something like their base aesthetic form, then juxtaposing these with their seeming opposites to create unexpected visual and aesthetic bridges. For example, her "Food Cycles" series features black-and-white images of odd, unexpected foods from other countries (see pages 178 and 179) Another series matched powerfully muscular male models, painted silver, with industrial steel tools. Somehow, she always manages to convey a rich and classically beautiful scene, regardless of the subject matter. And she's always excited about what's next.

You can see more of Francine's work on her website: www.francinezaslow.com.

Case study: Advertising photography

PHOTOGRAPHER: Francine Zaslow

STYLIST: George Simons

CLIENT: Panera Bread

USE: Advertising/Marketing Materials

LIGHTING: Strobe

CAMERA: Roliflex Camera with a Hasselblad digital back

LENS: 105mm

These two shots for Panera Bread were taken to illustrate how a customer might use Panera's freshly baked breads and pastries at home. A simple peanut butter and jelly sandwich was chosen to capture the hominess and beauty of their sliced bread. The lighting, a single diffused strobe, creates an engaging, natural feel that looks very appetizing.

Scones can be rather plain looking, so Francine set out to "romance" the image. Shooting overhead to emphasize the triangular shape of the scones, she took care not to stack or overlap the pastries, so as not to damage the fragile glaze on top. Configuring the scones in a narrow vertical formation worked best to fit the banner dimensions needed for the end product, an in-store display, encouraging a visual flow in tandem with the underlying fabric.

Francine used orange slices to emphasize the flavor of the scones, which also help to bring out the subtle color in the glaze. "The napkin helps to keep your eye moving up and down the image, adding a softness to the shot, a homespun feel, and also framing the shape of the scones," she adds.

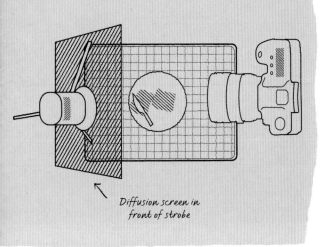

Diffusion screen in front of strobe

Case study: Advertising photography

PHOTOGRAPHER: Francine Zaslow

STYLIST: John Carafoli

CLIENT: The Catered Affair

USE: Advertising/Marketing Materials

LIGHTING: Strobe

CAMERA: Roliflex Camera with a Hasselblad digital back

LENS: 105mm

Francine used a simple top light filtered through a diffusion screen, along with a gridded strobe from behind the glasses to showcase the mojitos in this catering company shot. The repetition of the glasses and the glint of the salt create visual interest, while the lively colors and creative styling of leaves and natural twine keep the shot looking fresh and interesting.

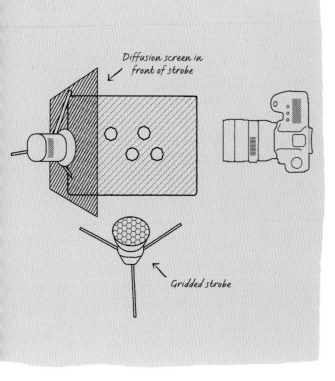

Diffusion screen in front of strobe

Gridded strobe

Case study: Stock photography

PHOTOGRAPHER: Francine Zaslow

STYLIST: Kelly Upson

CLIENT: Panera Bread

USE: Advertising/Marketing Materials

LIGHTING: Mix of daylight and strobe

CAMERA: Roliflex Camera with a Hasselblad digital back

LENS: 105mm

"You can't remake the same salad twice; the different shapes and curves of the leaves are all so uniquely interdependent," Francine explains. This salad, shot for Panera Bread, had to include specific quantities of each ingredient to communicate what would actually be served. Daylight was the key light in this shot, but a strobe was used to fill the background, with grid lights to lighten up the lettuce leaves. The occasional misting of fresh water helped to keep the salad alive as the team worked to build the shot.

"For me, it's like sculpture, molding and shaping forms and watching as the light wraps around the result, adding texture and depth and making it all feel just right," Francine says. "It's all about appealing to the senses."

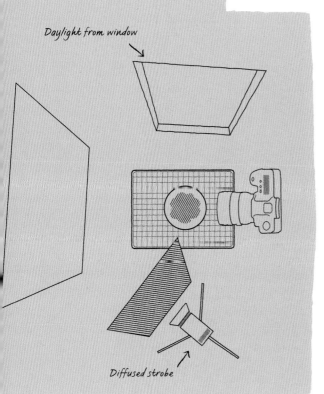

Daylight from window

Diffused strobe

Resources

Release forms

asmp.org/tutorials/forms.html
www.bapla.org.uk/index.php?option=com_content&task=view&id=30&Itemid=57

License agreements

asmp.org/tutorials/asmp-paperwork-share.html
home.the-aop.org/Downloads/p13_sectionid/2

Copyright guidelines and submissions (US, UK, AU and EU)

asmp.org/tutorials/asmp-paperwork-share.html
www.ipo.gov.uk/types/copy.htm
www.copyrightservice.co.uk/
www.copyright.org.au/
ec.europa.eu/internal_market/copyright/index_en.htm

Digital copyrighting

Digimarc: www.digimarc.com/default.asp
Digital Watermarking Alliance: www.digitalwatermarkingalliance.org/
E Watermark: www.ewatermark.com/

Creative commons

creativecommons.org/

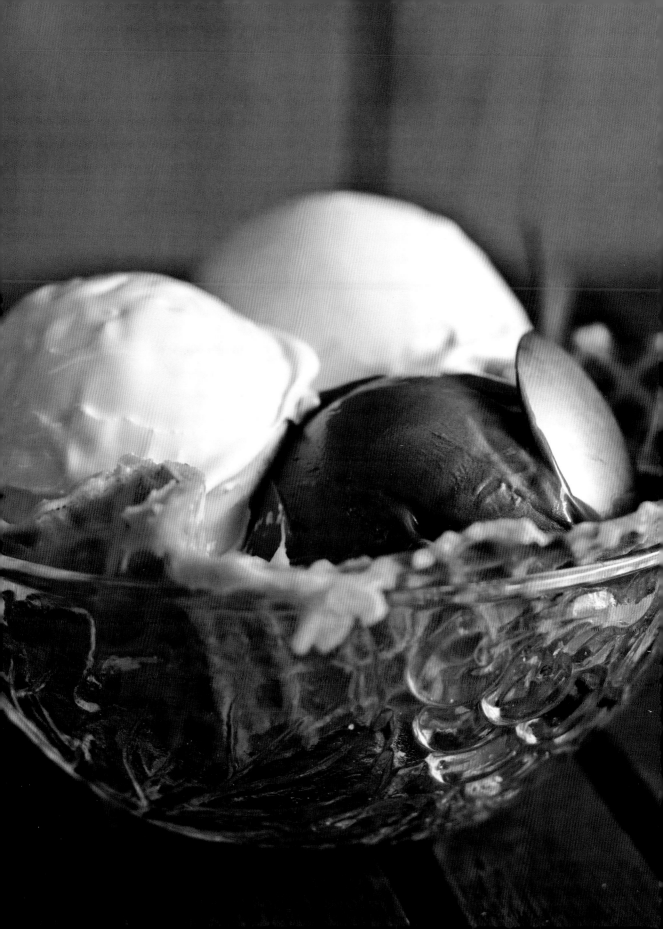

Index

Acknowledgments

There's nothing like sending out an email to your hero, asking for a bit of their time, and receiving a warm and welcome response to make your day. When I approached the contributing photographers for this book, I had no idea how many of my days would be made. I am still giddy with all the positive responses I received, and I am forever grateful for their sharing of time, anecdotes, experiences, and images. Lara Hata, Iain Bagwell, Sara Remington, Colin Cooke, Valerie Rizzo, Francine Zaslow, Lisa Golden Schroeder, Dennis Becker, David A. Land, Charlotte Tolhurst, Johan Vanbecelaere, Keiko Oikawa, Todd Porter and Diane Cu, and David Clancy: Thank you!

I also want to extend a personal note to my contacts at RotoVision, who placed their faith in me to create this book. I had long had visions of writing a food photography text, and am indebted to the warm reception and terrific feedback I received from Isheeta Mustafi and Jane Roe.